LIBRARY OF THE EARLY CIVILIZATIONS
EDITED BY PROFESSOR STUART PIGGOTT

EGYPT to the end of the Old Kingdom

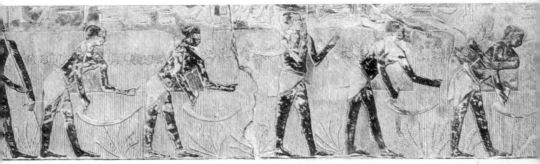

TO THE END OF

with 136 illustrations, 41 in colour

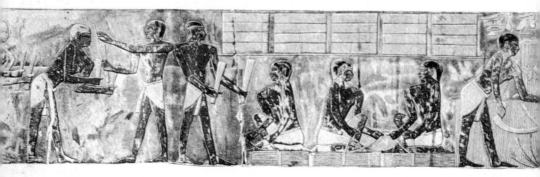

EGYPT

THE OLD KINGDOM

Cyril Aldred

Thames and Hudson

© 1965 THAMES AND HUDSON LTD, LONDON

FIRST PUBLISHED IN THE USA IN 1965 BY THE MCGRAW-HILL BOOK COMPANY.
THIS EDITION PUBLISHED IN 1982 BY THAMES AND HUDSON INC.,
500 FIFTH AVENUE, NEW YORK, NEW YORK 10110.
LIBRARY OF CONGRESS CATALOG CARD NUMBER 82-80981

PRINTED IN GREAT BRITAIN BY JARROLD AND SONS LTD NORWICH

CONTENTS

GENERAL EDITOR'S PREFACE

We have known about (or thought we have known about) 'The Ancient Egyptians' since childhood; rather more exciting and romantic than 'The Ancient Britons', but just as shadowy. We think of them perhaps as occupying a rather short, though remote, period in the perspective of antiquity, forgetting or ignoring if we do so that ancient Egypt had prehistoric beginnings at least six thousand years ago, and that the Egyptian state, as a Great Power of the ancient world, existed as a continuous documented entity for some two thousand five hundred years until its conquest by Persia, the native dynastic line not becoming extinct until a couple of centuries later.

Within such an enormous time-span–it is as though we ourselves had a continuous civilized cultural and dynastic tradition stretching back from today to the Early Iron Age–it is naturally proper to look at ancient Egypt in individual phases. In this book the first formative centuries of early Egyptian civilization are discussed and illustrated, the foundations upon which in subsequent periods the vast enduring structure of the Egyptian state was built, and once built, maintained. In fact, the genesis and rise of the earlier phases of Egyptian art, here demonstrated, are not only the necessary prelude to what followed, but had a vivid and arresting interest both in themselves, and in the wider world of ancient art as a whole.

This book is primarily concerned, and rightly so, with the tangible and visible memorials of early Egyptian culture, even in those periods, from 3000 BC or so, when in the strict sense of the word we are dealing with a literate civilization, with scribes able to make permanent records in writing. But we must be careful lest we misunderstand the nature of so much of early writing. Being ourselves members of civilizations permeated by complete literacy we may forget that many stages intervene between this state of affairs and an absolute ignorance of the basic techniques of writing and reading. There can in fact exist numerous variations on the theme of what has been called conditional literacy–the ability to represent sounds by an agreed set of arbitrary symbols need not always be exploited to its full potential. Limitations are of course imposed by the scarcity of persons who can acquire this

difficult technique, but more significant is the fact that in most ancient societies, and in many of the less complex communities of today, writing will only be used when absolutely necessary. It follows that literacy is conditional upon circumstances which demand and enforce its employment, and need not be in general use at all. It may be needed for recording business transactions, or it may be for announcing and demonstrating that the king has performed in exactitude the ritual performance before the gods on which depend not only his own existence and salvation, but that of his land and people. From such texts as the latter little history can be wrung save the bare names and perhaps the succession of rulers, and unfortunately much of the literacy of early Egypt is of this type. Fortunately the material culture of ancient Egypt survives in abundance, thanks partly to the dry climate of the Nile Valley and partly to the dictates of a religion which enjoined the faithful to make ample provision for the deceased in the other world by providing him with possessions commensurate with his social status this side of the grave. Furthermore, Egyptian art, from a very early stage of its development was not only representational, but much concerned with the visual presentation of situations and events.

We find in the story of the earliest Egypt a fascinating and intriguing counterpart, part parallel, part contrast, to the contemporary scene in Mesopotamia. By about 3500 BC in both regions there had grown up stone-using economies of agricultural peasants, and on the present showing Mesopotamia had considerable priority in the beginning of farming. Here too it looks as though we must recognize the origins of writing—again unless archaeology demonstrates unexpectedly its priority in another context. There is evidence to show that, by before 3000 BC, there was contact, and coming and going of some kind, between Mesopotamia and Egypt; even perhaps new population elements and the Semitic language which was to dominate any other linguistic components in Egyptian had come into the Nile Valley from Syria or Anatolia. Egyptian writing, though original and individual in itself, may nevertheless owe its origin as a concept—signs for sounds—to the scribes of the Twin Rivers. The smelting and working of copper may also have been introduced into Egypt from outside though copper ores exist in the Eastern Desert.

But although the purely archaeological evidence might appear to demonstrate a parallel development in the two areas, we know that in fact this, though superficially existing in material culture, was not the product of identical societies, nor was it leading to such a state of affairs. In Mesopotamia the beginnings of little independent city-states under tutelary gods,

rulers, councils and assemblies are perceptible, though later to be sub-merged in a familiar pattern of oriental despotism, but in Egypt from the beginning we are able to glimpse that essentially African figure, the omni-potent, rain-making, god-king. 'The prehistoric chieftain, a rain-maker and medicine-man, with magic power over the weather and therefore able to keep his people in health and prosperity' becomes, with the founding of the first historical dynasties, 'the Pharaoh, a divine being in command over the Nile and able to sustain and protect the nation'.

As with all early civilizations and, indeed, communities at whatever tech-nological level, that of Egypt takes on its individual 'form' at an early stage; individual in thought and language, social order and polity, art and archi-tecture. Economic and technological factors are indeed involved, and these might be considered basically the same all over the ancient world, but we must beware of the fallacy of thinking of them having a separate and pur-posive existence, independent of the people who created them. As an historian has recently remarked in such a context, it is silly enough to think of the French Revolution as a 'thing': still worse to regard it as a self-acting agent that 'stood up and did something'. What have been called the Neolithic and the Urban Revolutions must be seen in the same way, not thought of as independent and mysterious entities, but only in relation to the Sumerian, or Egyptian, or other peoples of antiquity whose actions and endeavours unconsciously brought them about. In this book we are shown, through their monuments and works of art, how the Egyptians faced their problems and founded their peculiar version of ancient civilization.

STUART PIGGOTT

INTRODUCTION

This book is an expansion of the 'chapter' written for *The Dawn of Civilization* under the general editorship of Professor Stuart Piggott. The intention in this work was to investigate briefly the various courses that had been taken by different human cultures in early times in their progress from savagery to civilization. The emphasis was placed upon the material remains of such civilizations as they had been revealed by archaeological exploration and reconstruction.

In tackling his 'chapter', the present writer limited himself to surveying the characteristic civilization which developed in Egypt from prehistoric times to *c.* 2000 BC, and which enjoyed a full flowering during the period of the Old Kingdom covered by Dynasties III to VI. The primal pattern that was established during this Pyramid Age was repeated, as far as possible, in ensuing periods whenever Ancient Egypt emerged from interludes of anarchy to become united again under the rule of a single divine king. The fact that the civilizations of the Middle and New Kingdoms and of the Late Period took rather different courses was entirely due to the operation of external forces which, despite all the Egyptian's instincts, turned into other channels his attempts to repeat his past.

If the present survey of Ancient Egyptian civilization is largely concerned with the material remains, particularly architecture and sculpture, that is a condition which the nature of the records largely imposes. For the literary evidence, especially for the first two dynasties, is extremely scanty, terse and ambiguous. Even for Dynasties V and VI, when biographical tomb inscriptions are not uncommon, the historical content amounts to very little. Even the fuller records, such as those of Weni, are far from explicit and political events at home and abroad have to be inferred rather than affirmed from occasional hints and *obiter dicta*. If the achievement of the Old Kingdom had to be assessed from its written remains, it would amount to little more than a gleaning from incomplete king-lists, funerary prayers, fragments of books of precepts and folk stories mostly recorded in a later age. The chief literary

legacy of the Old Kingdom – the Pyramid Texts – are a compendium of funerary liturgy and religious writings expressing in an archaic language all manner of beliefs from the primitive to the sophisticated. Their function was to enable the dead king to become identified with the gods, particularly the Sun-god Re. It is difficult for modern man, even with a reliable translation of these obscure texts, to project himself into the frame of mind and state of belief in which such religious ideas have meaning, particularly as we can no longer sense their poetry or their emotional content, except in rare glimpses. It is, however, much easier for us to appreciate the significance of the architecture and sculpture, fragmentary though much of it may be, which is the artistic expression of the same ideas and feelings that infused the religious writings and shaped the political and social structure of Ancient Egypt. In fact we are likelier to get a deeper insight into the nature of a pre-scientific culture, such as that of Old Kingdom Egypt, from the appreciation of its artistic modes than by an intellectual analysis of its philosophical beliefs in so far as they were ever expounded.

The wealth of art objects which have survived from this period is considerable and each year sees additions to its store. In choosing specimens to illustrate his theme, the writer has necessarily had to be selective, but he hopes that few pieces of great distinction have had to be excluded. The bibliography at the end of the book, however, should enable the more curious reader to follow the subject in as much detail as he desires.

In conclusion, the writer wishes to thank Mr Walter Neurath for encouraging him to refurbish his 'chapter' in its present form, and Mr Peter Clayton for many useful suggestions and other help. Whether their confidence and enthusiasm are justified must be left to the reader to decide.

<div align="right">C.A.</div>

CHRONOLOGY

In his *History of Egypt* compiled *c.* 280 BC, preserved only in extracts from other classical writers, the Graeco-Egyptian priest Manetho grouped the reigns of the various kings into thirty-one dynasties. This system is still employed by Egyptologists who further arrange the dynasties into longer periods, such as the Old, Middle and New Kingdoms, divided from each other by intervals of political confusion. The prehistoric ages are also grouped into certain broad periods named after various sites in Egypt where a distinct culture has been identified. The dating of such sequences by archaeological evidence has recently been controlled by C-14 analyses.

PREHISTORIC

Date	Period	Culture		Main sites
BC		Lower Egypt	Upper Egypt	
c. 5000	Neolithic	Faiyum 'A'		Faiyum depression
			Tasian	Deir Tasa
				Mostagedda
c. 4000	Chalcolithic		Badarian	El-Badari
		Merimda		Merimda
				Beni-Salama
	Early		Amratian	El-Amra
	Predynastic			El-Ballas
				Hū
				Abydos
				Mahasna
c. 3600	Middle		Early	Naqada
	Predynastic		Gerzean	
		Maadi		El-Maadi
c. 3400	Late		Late Gerzean	El-Gerza
	Predynastic			Haraga
c. 3200	*At this time the union was achieved of Upper and Lower Egypt under one king. This is the beginning of the Historic Period the main sites of discovery being Hierakonpolis, Memphis, Saqqara, Giza and Abydos.*			

HISTORIC

The Archaic Period

Dynasty I, *c.* 3200–2900 BC

Regnal Years

Narmer (Menes)
Hor-aha
Djer 40+
Djet
Den 30+

13

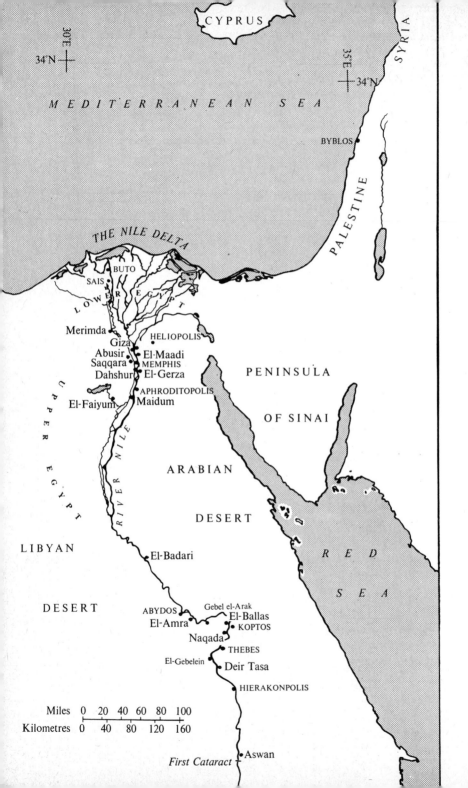

The Beginnings of Human Settlement

The retreat of the northern ice-cap, and with it the Atlantic rain-storms in the later phases of the Old Stone Age, produced a progressive desiccation over the Eastern Mediterranean. The park and grass lands of North Africa were transformed into shrinking regions of scrub and pasturage around failing water courses and scattered oases. This process continued well into historic times assisted by man-made devastation, by the overgrazing of thin pastures by herds of goats, and later by the camel, until a complete aridity had crept northwards to reach the shores of the Mediterranean.

With this climatic change, there came an alteration in the habits of the ancient nomads who had roved at will over the region, hunting the game that abounded in the

1 Palaeolithic flint hand-axes of the mid-Acheulian period, *c.* 200,000 years ago, from the high desert plateau behind Thebes

forests and savannahs. They have left traces of their passage in the worked flints of characteristic palaeolithic types that can be picked up on what is now high desert; and some hint of their hunting life may be gleaned from the rock drawings of food animals such as the antelope, elephant and Barbary sheep that they scratched in wadis all over the region. In their search for dwindling water-supplies, both animals and man were now forced into a closer proximity until the greatest concentration was reached on the verges of swamps and alluvium in the valley of the Nile, and it was at such a point of time that the first steps must have been taken in the domestication of some animals such as the pig, dog and long-horned cattle.

This natural process of corralling men from a wide area into a shrunken river valley produced a mixed popu-lation at a very early stage so that various branches of the Mediterranean race mingled their blood and speech before the dawn of history, though the Egyptians were to be re-inforced in historic times by infiltrations and migrations of different peoples from the Sudan, Libya and the Levant.

The transition from a food-hunting to a food-producing economy in this region cannot have been any sudden event. In prehistoric times the Nile Valley wore a very different appearance from what it has today and one would now need to go very far south in the Sudan to find similar conditions and a comparable flora and fauna. The early settlers found a valley full of swamps and pools left by the uncontrolled inundation of the Nile every year, in which vast thickets of reeds and sedge grew to over a man's height and acted as cover to every kind of pond fowl and freshwater fish, besides hippopotami and less desirable creatures such as crocodiles. The elephant, lion, ass, ibex, Barbary sheep, antelope, wild ox and smaller desert game frequented the wadis that flanked the river, since up to late historic times these ancient water courses

still resembled parkland with low shrubs and flowering meadows. Even today infrequent rain-storms far out over the desert can flood these same dried valleys, producing in a short time an abundant ephemeral flora with its attendant insect and animal life. It is probable therefore that there was not much compulsion on these first settlers to change their way of life radically, and they doubtless enjoyed a mixed economy, trapping birds and fish among the pools, hunting for game in the wadis and exploiting such marsh vegetation as papyrus and the wild Abyssinian banana (*Musa ensete*), and such catch crops as barley or emmer wheat dibbled crudely into chance-flooded ground after rain-storms, in much the same manner as that employed by the primitive Hadendowa and Abebdeh of the Sudan in recent times. While such a crop was growing the family would be obliged to squat in the vicinity and adapt its pastoral and hunting life to more settled conditions.

The Change from Hunting to Farming

At some stage in this misty past a group of these squatters must have taken the momentous step of deciding to stay put and to grow these cereals as a main food crop. Perhaps over-exploitation of the marsh plants caused a local shortage of such food. The papyrus and the *ensete* would certainly be eradicated by the draining of swamps in order to grow wheat and barley. Such food-grains and the techniques of raising and harvesting them were almost certainly introduced into Egypt from an Asiatic, perhaps Natufian, source. What was novel in their cultivation in Egypt was that there only the most primitive equipment was sufficient to grow bumper crops. The inundations of the wayward Nile, not yet confined by a stable climate and irrigation works into a more or less predictable channel, would devastate tracts of land leaving behind a rich mud on which grain needed merely to be scattered

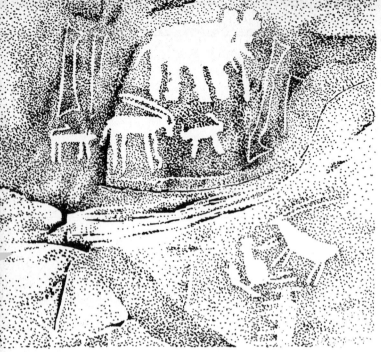

2 Prehistoric rock-carving of food animals from Hôsh, Upper Egypt

3 Prehistoric rock-carving of a lassoed giraffe beside the Nile near Gerf Hussein, Upper Egypt. On the extreme right is a later carving of a Gerzean boat

and trodden in by foot or hooves in order to grow. The Nile flood rises in July with the falling of tropical rains on the Abyssinian uplands and subsides in November when seeds can germinate and ripen in the gentle heat of winter and spring. The first Egyptian farmers therefore hardly needed to till and manure their fields; such work was done for them by a beneficent Nile.

The growing of cereals on a larger scale was the first stage in a revolution that was to replace a food-gathering nomadic existence by an urban civilization based on agriculture, for grain could not only be grown by man at his will and without great effort, it could also be readily stored on the dry desert margins. Not only need there be no immediate shortage of food, but more food could be produced than the local community required for its needs. By upsetting the balance of nature, man was momentarily relieved from the constant search for the means of subsistence and had leisure in which to specialize in various

skills. It enabled him, for instance, to develop that complementary branch of agriculture, the raising and breeding of domestic animals.

But this new and artificial mode of life did not solve all the problems of man's existence; it merely altered the rhythm of their occurrence. More food encouraged the production of more people and their animals. More land had to be cultivated to grow more grain and a start was made on a spiralling process that still continues today. The annual inundation of the Nile had to be tamed, its prodigality distributed over wider tracts of ground by irrigation works, and its fertilizing silt spread on fields newly won from the desert. The draining, clearing and irrigating of land in the Nile Valley was most effective when done on a large scale, and co-operative effort in such work would become inevitable as the settlements on the banks of the Nile increased in size and numbers. This co-operative effort would be particularly needed at the

critical moments when the floods began to rise and fall and hard and extensive labour had to be exercised within a short space of time. The transformation of the destructive power of the inundation into a beneficent force accustomed the Egyptians to an organized way of life and led to the emergence of local political institutions to direct such enterprises and ensure their success. The logical outcome of this process was the unification of the entire country under a single government as small families of settlers gradually grew into village communities and these in turn grouped themselves into larger districts as the exploitation of the valley became more intensive.

The first steps in harnessing the Nile Flood, in developing a thriving agriculture and creating a political system to ensure the persistence of the artificial conditions thus secured, were all taken by the prehistoric Egyptians.

The Early Predynastic Period

The various stages in this long struggle towards civilization can be traced at different places in Upper and Lower Egypt, where excavations have revealed cultures of distinctive types which may be grouped into two broad categories. An earlier phase has been identified covering much of the material remains as found at the neolithic sites of Deir Tasa in the South, and Faiyum 'A' and Merimda in the North, and extending through the Chalcolithic cultures of El-Badari and El-Amra, again in the South. The later manifestations of this prehistoric culture are sometimes referred to as the Early Predynastic Period. To the Middle and Late Predynastic Periods belongs the second category of material which has been excavated at sites near El-Gerza in Lower Egypt and notably at Naqada in Upper Egypt. The name 'Late Gerzean' has been applied to a common version of this culture which extended over both Upper and Lower Egypt just before the historic period.

From the material remains of this first phase of prehistoric cultures, we are able to build up a picture of the early Egyptians, and to see how they gradually adapted themselves to a settled agricultural way of life which at the end of the period, towards 3600 B C, can have differed little from the culture of the pagan tribes of the Upper

Ill. 5

21

5 A reconstructed view of an Amratian village of *c.* 3800 BC based on the archaeological ▷
evidence. The 'bee-hive' huts of the villagers are woven of grass and reeds; the chief's house is
larger and rectangular in plan. The shrine of the local god is distinguished by the poles with
streamers attached that stand before the threshold, and by the fenced-off sacred enclosure.
A woman squats before a horizontal loom pegged to the ground and by the river a patch of
drying mud left by the falling Nile after the annual inundation is being sown with barley. The
seed is turned in by women and children using wooden hoes and a man follows them dragging
a log across the ground to smooth it down. A party of hunters returns with their kill – ibex,
gazelle and desert hare. In the foreground the chief, distinguished by his skin cloak and ostrich
feather head-dress and wearing an ivory amulet, squats on a low stool giving advice

Nile today. They appear to have been a slight race of
medium height with long narrow skulls, brown skin and
dark wavy hair, though their physical remains are scanty
except in the South. We find them camping at first on the
verges of the marshes under the protection of reed
shelters or windbreaks; but at Merimda in the North
there was a huddle of low oval structures each built of
lumps of mud with a pot let into the rammed earth floor
to collect the rain that leaked from the thatch. This primi-
tive village with its rudimentary houses and a communal
granary consisting of mat-lined pits suggests a distinct
social advance even if its standard of comfort was not
high. The remains from Faiyum 'A' date from *c.* 5000 BC.

Both wheat and barley were grown from Neolithic
times. Wooden sickles, set with flint teeth, and a flail for
threshing have survived from the Faiyum 'A' sites where
storage pits were also found lined with mats. Querns and
mealing-stones from all sites show that milling was a
household industry. Basketry was practised as early as the
Faiyum 'A' period, where besides platters, a notable boat-
shaped container has come to light. Mats were woven of
grasses and rushes and used for lining both grave and
grain pits. Another textile, a coarse kind of linen found
also among the Faiyum 'A' deposits, shows that the
growing and processing of flax was understood even
from the earliest days, and this pre-supposes that spindle
whorls and looms also existed, though the latter have not
been recovered.

The technique of weaving linen improves steadily
throughout the period. Garments were also made from

Ill. 4

4 A boat-shaped
grass basket found in
a storage pit in the
Faiyum, *c.* 5000 BC

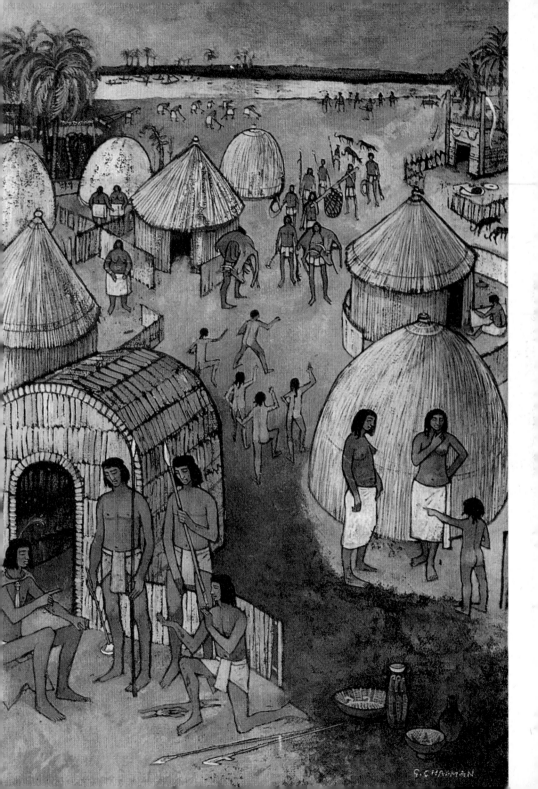

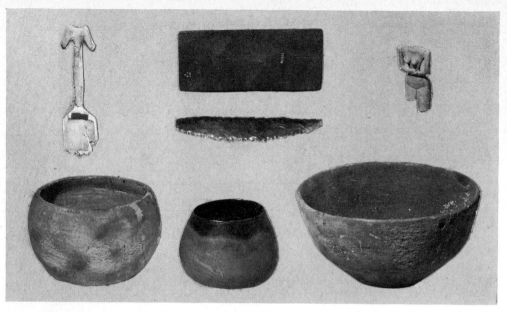

6 By 4000 BC the people of El-Badari were making tools and utensils suitable for village life and community use. They ground cosmetics on stone palettes, used ivory spoons and knives chipped from flintlike quartz. Their pottery was no longer coarse and ill-fired, the jar in the centre has fine thin walls and a polished surface. The pottery figurine possibly had a magical purpose – to serve the dead

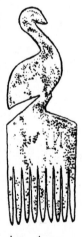

7 An Amratian ivory comb decorated with a bird, from Naqada

animal skins sewn together by means of bone needles, and skill in softening and tanning hides is evident at Badari. A remarkable improvement in objects of luxury and personal adornment can also be traced from the perforated stone and shell disk beads of Faiyum 'A' and the stone bead necklaces and girdles of the Badarians. Bracelets of ivory and shell are also common. Eye paint made from green malachite is found at all predynastic periods, and the stone palettes on which the cosmetic was ground with a stone muller becomes standard equipment for nearly every burial of note. The wild castor plant furnished oil for cleansing and softening the skin. Combs were made from bone or ivory and in Amratian times are decorated with figures of birds or animals.

Tools and weapons were almost exclusively of stone and flint. Arrows were tipped with bone or flint points. The throw-stick was known in a form that persisted almost unchanged into Pharaonic times, and was prob-

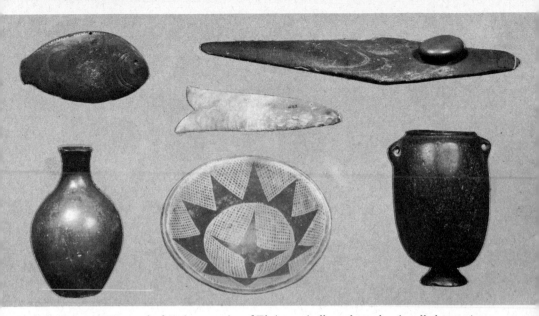

8 The Amratians, named after the type site of El-Amra, hollowed out lug-handled stone jars – the forerunners of one of the most characteristic products of Ancient Egypt. They made black-topped pots in various shapes and red burnished pottery with white-slip decoration. A fish-tailed lance-head, and two cosmetic palettes, one fish-shaped and the other with its round rubbing-stone, are shown

ably employed, as then, for fowling. A mace with a disk-shaped stone head is common in the South after the unwarlike Badarian period, but begins to be replaced by the northern pear-shaped head at the end of the Amratian period. A fish-tailed lance-head is characteristic of the deposits of Amratian times, but cannot have been particularly effective as a weapon and may have been an amulet.

Ills. 8, 11

At this period, food appears to have been fairly plentiful. Dogs, goats, sheep, oxen, geese and, in the North, pigs had been domesticated, and game, fish and fowl abounded. It has been suggested that grain was boiled for porridge as well as baked for bread. Cooking vessels and food containers were made of pottery and this industry shows a steady advance from the coarse clay cups and bowls of Faiyum 'A' and the ill-fired ware of Deir Tasa, through the fine thin-walled bowls of Badari with their combed and polished surfaces to the red burnished pottery of the Amratians, notable for their predilection for

Ills. 6, 9

25

9 A small red and black pottery vessel from the cemetery at Naqada. The characteristic black top is caused by the pots being fired standing upside down with their necks sealed in ashes and air being allowed to reach the main body of the pot

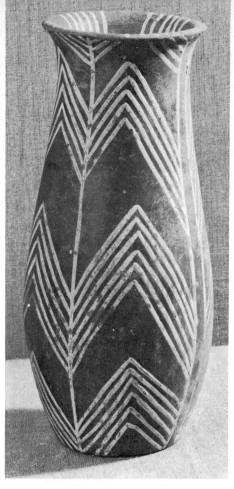

10 An Amratian pottery vase in red ware with cross line decoration in white slip, before 3600 BC

Ill. 10 fanciful shapes and white slip decoration or carbonized surface variegation. In Amratian times also there first

Ill. 12 appear in the South vases hollowed out of stone, though archetypes are known from the earlier northern site of Merimda. These are the forerunners of one of the most characteristic products of Ancient Egypt at all periods of her history.

Ills. 14–18 Among these objects of utility should also be included a number of ivory statuettes mostly of women and doubtless included in burial deposits to serve magically the needs of the deceased. The earliest of such figurines comes from Badari and even at this remote period a dimple

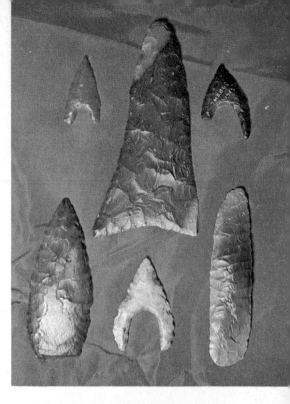

11 Flint implements from Upper Egypt. The arrow-heads are of the type known as 'hollow-based tanged Faiyum points'. In the centre is a fish-tailed lance-head and the more normal type of lance-head (bottom left). Below right is a finely worked blade with 'ripple-flaking' technique across its surface

12 Vase in the shape of an elephant, carved and hollowed from pink limestone, with holes for suspension. The lower part of the trunk has been broken off. Late Predynastic or Early Dynastic, before 3000 BC

13 Pottery box, red on buff ware, from El-Amra, but of Gerzean date, decorated with dark red figures of kuddu and fish nibbling at food. Also shown on the box, but not in the illustration, is a characteristic Gerzean boat

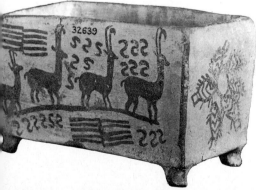

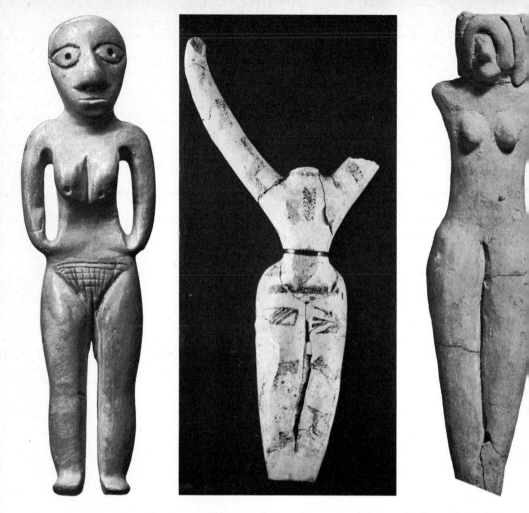

above each buttock is represented by a shallow drill-hole in precisely the same fashion as was employed on much more sophisticated examples which occur up to three thousand years later.

The intellectual and spiritual life of these early dwellers on the Nile can never be known to us. That they believed in a kind of hereafter for some members of the community is evident from the many burials that have been found on hut sites and in the later cemeteries at the various centres. The body is usually crouched on its side as though in sleep or awaiting re-birth and the presence of worldly goods shows that the after-life was not expected to differ

Ill. 19

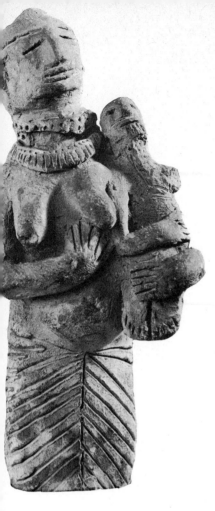

14–18 The female figure is the subject most commonly represented in the clay figurines of the Predynastic period. The female represented is either the mother goddess or an idealization for magical purposes. They are made of Nile mud which turns red when well baked. *Ill. 14.* A Badarian ivory figurine of a woman, *c.* 4000 BC. This type of ivory figurine was doubtless included in the burial deposits to serve the magical needs of the deceased. *Ill. 15.* The dancing female is Amratian, but the slender form unlike the Gerzean figures (*cf. Ill. 18*) recognizes the significance of human anatomy. The rough painted designs, a combination of geometric patterns and semi-naturalistic animal forms, represent dress ornaments, or possibly tattooing. The female figurine *Ill. 16*, represents the transition period Amratian-Gerzean. *Ill. 17*, a buff pottery statuette of a mother and child, dates from before 3000 BC. *Ill. 18*, an ivory figurine of the Gerzean culture, from Naqada, is still no more than a primitive totem

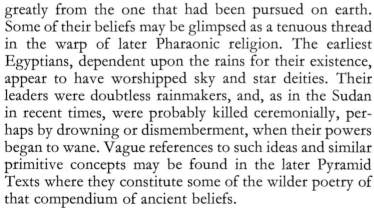

greatly from the one that had been pursued on earth. Some of their beliefs may be glimpsed as a tenuous thread in the warp of later Pharaonic religion. The earliest Egyptians, dependent upon the rains for their existence, appear to have worshipped sky and star deities. Their leaders were doubtless rainmakers, and, as in the Sudan in recent times, were probably killed ceremonially, perhaps by drowning or dismemberment, when their powers began to wane. Vague references to such ideas and similar primitive concepts may be found in the later Pyramid Texts where they constitute some of the wilder poetry of that compendium of ancient beliefs.

Ill. 94

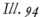

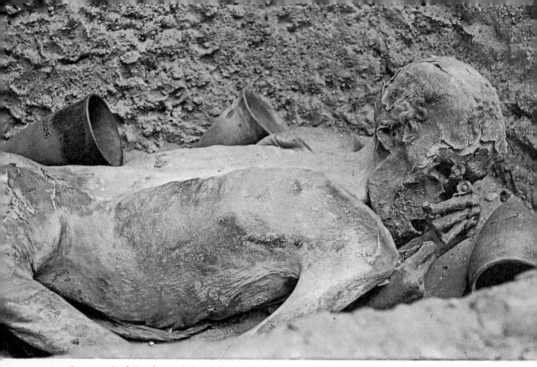

19 In crouched Predynastic burials the body was invariably laid on its left side as if asleep and surrounded by pots, tools and offerings to accompany the deceased into the next world. The graves themselves were merely shallow pits dug in the sand of the desert plateau, the body occasionally being wrapped in a reed mat. The marvellous state of preservation is due solely to natural means, the action of the hot sand upon the tissues, resulting in complete desiccation

The political system under which these people lived must also be surmised. Probably communities were small, self-supporting and comparatively isolated around village centres: but the presence of copper pins and glazed steatite beads (steatite is a kind of greyish-green soapstone) in Badarian and Amratian times suggests that trade was carried on with more advanced cultures elsewhere.

The Later Predynastic Period

The essentially African culture of the Early Predynastic Period might have remained sterile at this level, as it did apparently in the Sudan, where a Badarian type of culture persisted for a much longer time, if it had not been fertilized by contacts with a different civilization coming from Asia. During this period some significant changes were introduced from without. The use of copper becomes more widespread, suggesting closer connections by trade or expansion with Sinai or the Eastern Desert where copper ore was mined. Henceforth that metal becomes commonplace for tools and weapons, though flint continued to be employed in Egypt for a very long time for such specialized purposes as the grinding of stone vessels, the carving of ivory and the reaping of grain.

But there is also evidence for influences from farther abroad. Three Mesopotamian cylinder-seals of the Late Uruk or 'Proto-literate' Period have been found in Egypt, one definitely in a Gerzean grave at Naqada, and from now on the imprinting of clay seals by rolling incised cylinders over them becomes the normal Egyptian practice until the introduction of the stamp seal 1500 years later. Certain fantastic animal motifs in contemporary *Ills. 20, 32* Mesopotamian art also creep into Egyptian decoration such as the device of two intertwined serpo-pards, the

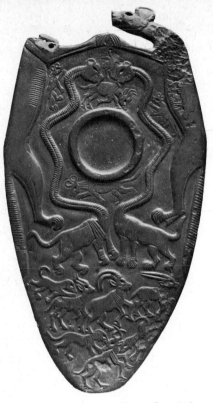

20 The 'Oxford Palette' illustrates typical long-necked mythical creatures. Their necks wind upwards to encircle the central depression which held the ground-up cosmetic. Below, hounds attack fleeing ibexes. The eyes of the animals are shown as cavities, *cf. Ill. 30*

21 Wall-painting from a Gerzean tomb at Hierakonpolis, probably of an important chief. The decoration is an expansion of the themes shown on the Gebel el-Arak knife handle (*Ills. 23, 24*), with ships of differing types and confrontation of lions

winged griffin and the interlaced snakes. Such ideas were alien to the Egyptian imagination which was sober and more logical in its creative utterances, and the innovations had a relatively short life; but their very adoption shows the force of their impact.

Ills. 23, 24

The most celebrated of such foreign-inspired objects is the ivory handle of a flint knife found at Gebel el-Arak and now in the Louvre. This is carved on one side with the figure of a Mesopotamian type of hero subduing two lions. The same unusual theme appears in a wall-painting

Ill. 21

on a Late Gerzean tomb at Hierakonpolis which is one of the earliest brick-built structures in the South. The reverse side of the ivory shows ships with characteristically vertical prows and sterns rather like the *belems* of the Tigris.

Another and rather less transient influence is to be seen in Late Gerzean times with the introduction of a monumental style of building based upon mud-brick. Archi-

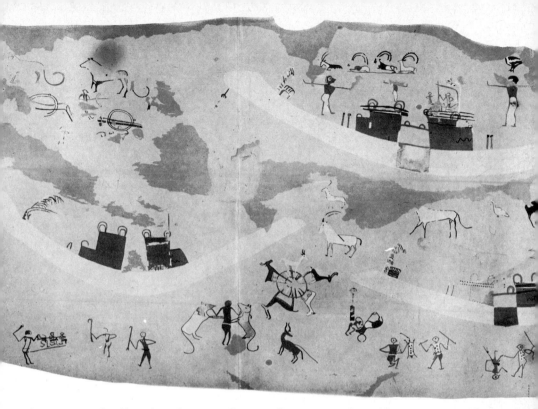

tecture gradually abandons a form of construction in perishable vegetable materials such as reeds, papyrus stalks, palm branches and rush matting, and adopts instead a purely tectonic form determined by the use of sun-dried mud-brick struck from rectangular wooden moulds. This technique with its emphasis upon the pilaster and the recessed panel has some affinities with that employed in Mesopotamia where a long tradition of building in brick had existed.

Ill. 22

Even more important is the apparently sudden emergence of a graphic method of recording speech which is beyond a merely pictographic stage. Hieroglyphic writing, which first appears on the slate palettes in Late Gerzean times, already uses ideograms and phonograms, concepts which had developed in Mesopotamia from a more rudimentary system.

The introduction of writing in Egypt coincides with a strengthening of the Semitic speaking element in its

22 A pottery model house of the Gerzean Period from El-Amra. It represents a substantial house, evidently built of wattle and clay with walls making a distinct batter, similar to private dwellings built in Nubia recently. The door and windows would have been made of beams of local wood and the roof of thatch and mud

culture at the expense of its Hamitic and Berber components. Perhaps the two phenomena were interdependent, the Semitic aspects of the literary language becoming more dominant because the system of writing in origin had been devised to record a Semitic manner of speech. Nevertheless, there is a southward drift of people into the southern culture zones at this period which affected the physical character of the population, the long-headed Mediterranean type being modified by a broader-headed mountain people perhaps from Anatolia or Syria.

All these innovations, however, have no appearance of being imposed by conquest. The Gerzean culture in the South is a development of the Amratian with its predominantly African character. There was not so much the imposition 'of foreign forms, as the infiltration of new *Ills. 23, 24* ideas and techniques. The Gebel el-Arak knife-handle has a distinctly alien appearance, yet traditional Egyptian types of boat and animals also appear on it. The cylinder-

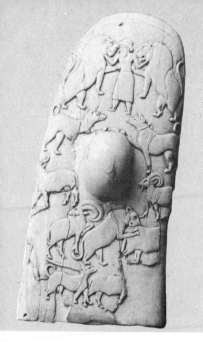

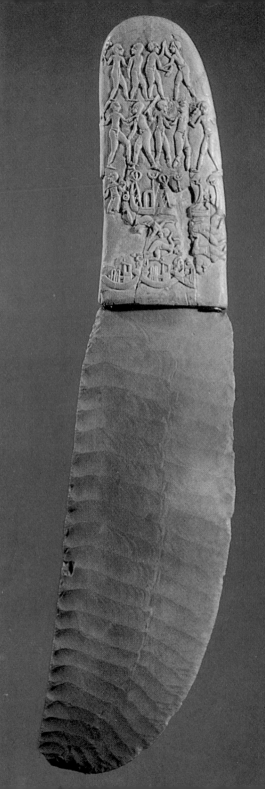

23, 24 One of the most celebrated discoveries from the Gerzean period in Egypt is the knife from Gebel el-Arak. The thin flint blade is a fine example of ripple-flaking but it is the carved ivory handle which is of prime importance. The reverse (*Ill. 23*) shows, subduing two lions, a hero who resembles the Mesopotamian Gilgamesh 'Lord of the Beasts'. This same unusual theme appears in a wall-painting in a Gerzean tomb at Hierakonpolis (*Ill. 21*). Below the hero stand two hunting dogs and beneath these are ibexes, one of which is being attacked by a lion. The obverse (*Ill. 24*) shows a water-battle in progress. In the upper row, the boats have vertical prows and sterns rather like the *belems* of the Tigris, in the lower they have the normal appearance of Egyptian boats of Gerzean date

seal as employed in Egypt was of wood as well as stone and is incised with inscriptions rather than decorative designs. Similarly, the hieroglyphs are pictures of objects seen with Egyptian eyes and rendered with the characteristic observation of the Egyptian who could reduce a natural form to a heraldic device better than most ancient peoples. In short, what now permeated the native cultures were principles and ideas rather more than style. A foreign 'know-how' was quickly seized upon and enthusiastically adapted to Egyptian conditions by a people ripe for change.

All the evidence is that this spread of foreign influence came from the North, but our knowledge of conditions in the Delta at this period is lamentably scanty. It may be that the innovations came through an intensification of trading in the Eastern Mediterranean with the development of the sea-going ship. This invention was doubtless made in a large timber area, which Egypt was not, and it has been plausibly suggested that Byblos in the Lebanon was the most likely region where boats able to sail on the coastal waters of the Levant were developed. Wherever the sea-going ship may have been invented, the Egyptians were as quick to adapt it to their own uses as they were at a much later date to exploit the possibilities of the horse-drawn chariot, another foreign importation. The opening up of the Eastern Mediterranean by shipping must have increased considerably the number of contacts between various peoples in the area and may have stimulated the almost coeval flowering of the civilizations of Crete and Egypt.

The Gerzean Culture

The character of the Gerzean culture of Lower Egypt has emerged from the study of deposits at El-Gerza and other sites in the Faiyum, and its southern version has been

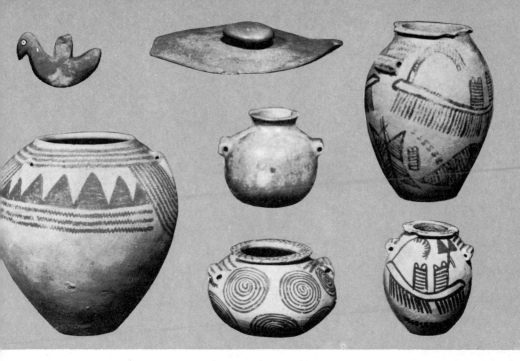

25, 26 The Gerzean culture known from the type-site of El-Gerza in the North, is found in the South to permeate the Amratian gradually and supersede it, notably in the vast cemeteries of Naqada and El-Ballas. The pottery is mostly decorated in red on a buff ground with designs of ships (*cf. Ill. 27*), stylized water and hills, and spirals resembling the conglomerate from which the contemporary stone jars were made. Such jars (an example is shown centre) became common, probably owing to the invention of a cranked brace and fly-wheel. By means of flint 'bits', easily discarded when worn, the hollowing out of such vessels was much less arduous. Also shown are a cosmetic palette and rubber, and a slate chest-ornament in the form of a bird. *Ill. 26*, below right, is a Gerzean wavy handled jar

found permeating and superseding the Amratian culture at the vast cemeteries of Naqada and Ballas near Koptos. The transition to the early dynastic style of historic Egypt is thereafter progressive.

The Gerzeans are generally similar in their Mediterranean racial type to their predecessors but their skulls are broader and their faces longer. Their pottery includes wavy-handled jars, similar to those found in Palestine, and a light coloured ware, usually pink or buff, painted with linear decorations in red. The motifs include triangular hills, flamingoes, ibexes, the *ensete* plant and human figures. Some pots are decorated with designs that

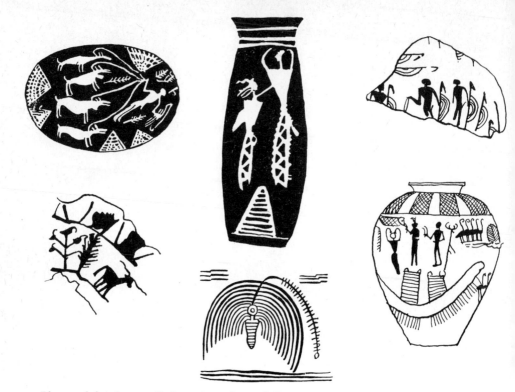

27 Plant and figurine motifs from Amratian and Gerzean pots. The motifs include triangular hills, ibexes, the *ensete* plant (bottom row, centre), ships, a hunter with his dogs on leash, and warriors. Ships are a particularly popular decorative motif on pots of the period and are often shown with the central cabin and with what may possibly be a small square sail forward to assist sailing upstream, i.e. south

Ills. 13, 25, 27

Petrie has interpreted as shrine-like cabins and emblems representing deities, but other authorities reject this explanation. Clearer evidence for the design of prehistoric boats comes from a fragment of painted textile from *Ill. 28* El-Gebelein now in Turin, where ships with rowers and steersmen as well as cabins are depicted. Other Gerzean pots are shaped and decorated to simulate the stone jars and vases that now become common, probably because the introduction of a cranked brace with weights acting as a flywheel and able to take expendable flint borers made the hollowing-out of such vessels much less arduous. This *Ill. 29* tool, the *hem*, is shown as a hieroglyph. The knapping

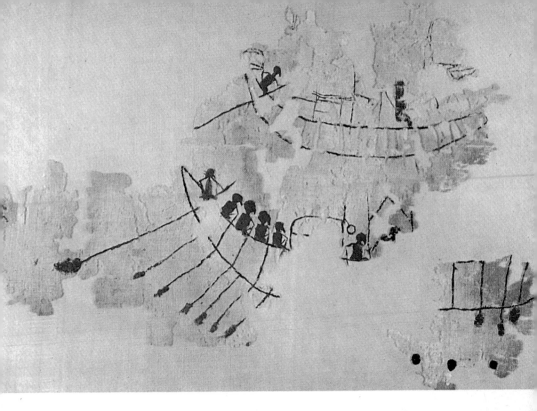

28 Fragments of painted linen from a Predynastic tomb at El-Gebelein. The fabric is linen with a very fine thread; the delicate task of reassembling it took four years. Both vessels shown have a double cabin amidships and a steersman in the stern. Unlike most representations of human figures from prehistoric Egypt, Mesopotamia and the Mediterranean area, these are not 'beak-nosed' and wear beards. (*cf. Ill. 21* for the boat)

of flint implements achieved an unrivalled perfection and is particularly evident in the curved knives of thin section with regularly chipped blades rippled like ribbed sea sand. The technique is referred to as 'ripple-flaking' and was obtained by using a punch, probably of wood.

An alkaline vitreous glaze which had been used sporadically in Badarian times to coat small trade objects such as beads is now employed to produce a unique material, Egyptian faience, which had an unfading popularity until Arabic times. This substance was apparently invented and developed by a people living on the western borders of the Delta and was named after them.

29 The *hem* hieroglyph, a stylized form of the usual stonemason's cranked brace and flint borers

In the later phases of the Gerzean period from about 3400 to 3200 BC there are signs of a more intensive political activity and it is supposed that during this period a struggle for predominance arose between the rulers of Upper and Lower Egypt. It is at this stage that the geographical differences between Upper and Lower Egypt become important historically – Upper Egypt consisting of the narrow valley that stretched northwards from the rocky barrier of the First Cataract in the South, and Lower Egypt comprising the Delta in the North.

The Physical Environment

Upper Egypt, confined to the strip of land bordering the Nile for most of its length between cliffs, presented a rather less hospitable environment than the broader horizons of the Delta and the Faiyum depression. The Upper Egyptian could see the hostile desert hemming in the cultivation on both sides and knew that only his unrelenting toil kept the red sands from swallowing the black fertile land he had so strenuously won. His work of irrigating and draining these verges was most effective when performed communally, and he early learnt to co-operate with his neighbours in this task. The Nile waterway that flowed through the entire region assisted the process of cohesion in another way: it provided an easy means of communication with every part of the area.

Lower Egypt, on the other hand, was a broad extent of rivulets, creeks and marshes isolating tracts of meadowlands and the wider pastures on the eastern and western borders where flocks of goats and sheep grazed and cattle were bred. Its Mediterranean climate was wetter and less harsh. It was a lush region of vineyards and gardens: fish and fowl were plentiful and deposits of salt for preserving them were near at hand. The broad stream of the Nile which unified Upper Egypt, by dividing anciently into

twelve branches and innumerable rivulets, parcelled Lower Egypt into a number of principalities clustered around individual village or town centres. While Upper Egypt looked northwards to its neighbour, Lower Egypt faced the Mediterranean. Its seaports had contacts with the lands of the Levant and the Aegean. Its population was more cosmopolitan, with Libyans on the west and Semites on the east. In early days it seems to have been culturally more advanced than the rustic South; in historic times it maintained its lead as the centre of the arts and crafts, probably attracting skilled workers from near and far. Unfortunately much of its past is lost beneath vast accumulations of Nile silt and we are obliged to assess its achievement not so much by the forms that have come down to us, as by the outline of the gaps that their absence has made.

It would, however, be wrong to exaggerate the differences between the two regions. They shared a common language and the same material and spiritual culture. Certain fundamental religious concepts, such as that a divine power was immanent in certain men and animals, were accepted by both, even though the exact form of deity varied somewhat from place to place. The underlying unity of thought and feeling in all Egyptians is evident from the way the civilization of the whole land blossomed profusely as soon as the two parts were rejoined in vigour and purpose after periods of schism.

Nevertheless, there is a kind of antithesis between Upper and Lower Egypt, which the Egyptians themselves recognized by referring to their country as the Two Lands, an antithesis which particularly appealed to them since they saw the world as essentially a duality. While the North was the cultural leader, it was the South that provided the disciplined political direction. The basic unit of government in both regions was the community centred around a village with its local version of one of

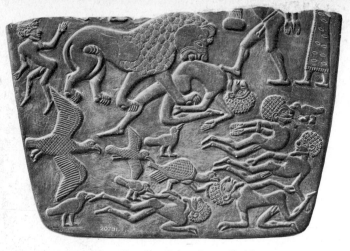

30, 31 The 'Two Gazelles Palette' so called because two gazelles are shown on the reverse in heraldic opposition. The fragment represents a battle-scene with defeated enemies being devoured by a lion and birds of prey and a personified district being led captive. The features of the enemy are un-Egyptian. The larger-than-life lion probably represents the victorious king. This palette is the earliest existing example where the convention of representing the eyes as mere cavities (cf. Ill. 20) is no longer used. Eyes are outlined in both men and animals by a narrow border ridge (cf. Ills. 31, 32, 34). Also now firmly established is the convention of showing hips and limbs in side-view and frontal eyes in a profile head that was to continue for centuries through Egyptian art. Ill. 31, a fragment of a slate palette from Hierakonpolis shows the king as a bull goring an enemy, probably a Libyan. One of many epithets of the king in later laudatory inscriptions was 'mighty bull' (cf. Ill. 32). The standards with fetishes hanging from them (Ills. 36, 37) have hands which grasp a rope, once probably hauling along a group of enemies as on the mace-head in the Petrie Collection

Ills. 30, 31

the universal deities, and under the leadership of some chieftain. These districts or *nomes* were the smallest particles into which the country split in times of disorder. But we can detect, even in Late Gerzean times, the emergence of a pattern that was to be repeated again and again in Egyptian history: it was the ambition of Southern princes that led them to extend their sway over ever larger tracts of the valley until they had created a unity out of the former anarchy, one kingdom out of a conglomeration of rival districts. It is the character of these conquests in historic periods that may enable us to understand how this unification was achieved for the first time.

The Transition to the Dynastic Age

Vivid evidence for the political activity that created
Dynastic Egypt comes from a number of votive palettes
and mace-heads which have been recovered from various
sites, notably from Hierakonpolis, the ancient Southern
capital. The most significant of these carved objects, in
fact one of the most important monuments to have sur-
vived from Ancient Egypt since it shows in embryo
nearly all the characteristics of Pharaonic art, is the slate
palette of King Narmer (or perhaps Meri-nar). On each
side, at the top, the name of the king may be read within
a palace building: certain other explanatory hieroglyphic
labels also appear which though obscure in meaning
render this one of the first documents in the written
history of Egypt and emphasize that we now have to do
with a civilized state. The king's name is flanked by heads
of Hathor, or possibly Bat, a primeval cow and mother
goddess, at whose shrine this palette was probably
dedicated; and we can see in the woman's face emerging
from the cow's head the epiphany of the gods in human
form that seems to come simultaneously with the
appearance of these early kings.

On the obverse of the palette, the larger-than-life figure
of Narmer is shown wearing the *deshret*, the Red Crown
of the Delta cities of Buto and Sais, later the characteristic

Ills. 30, 31

Ills. 32, 34

Ill. 33

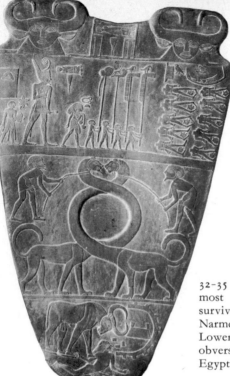

32-35 The slate palette of Narmer is the most important single monument to have survived from Early Dynastic Egypt. Narmer is shown wearing the Red Crown of Lower Egypt (the *deshret*, Ill. *33*) on the obverse and the White Crown of Upper Egypt (the *hedjet*, Ill. *35*) on the reverse. Many

headgear of the Pharaoh as King of Lower Egypt. The Red and the White Crowns are often shown as hieroglyphs. The king is preceded by his priest and four standard-bearers carrying fetishes: his sandal-bearer and foot-washer brings up the rear of the procession which is inspecting rows of corpses whose bound arms and severed heads proclaim them to be native rebels. The place of slaughter has been identified from the glyphs above the bodies as Buto. The central register of this highly organized design shows a circular depression around which are disposed two serpo-pards and their attendants. This enigmatic foreign-inspired device has been explained as representing the theme of union. At the bottom of the palette the king as a 'strong bull' breaks down a township, with a large palace or temple and smaller houses within, and tramples upon a foreign rebel, probably a Libyan.

The reverse shows Narmer, accompanied by his sandal-bearer, wearing the White Crown of Aphroditopolis, the

Ill. 35

of the motifs appear on other less well-preserved ceremonial palettes of the period, compare the serpo-pards (*Ill. 20*) and the rampaging bull (*Ill. 31*). The hieroglyphs, some obscure in meaning owing to their archaic form, render this palette one of the first documents in the history of Egypt

hedjet, which was to become the emblematic headgear of the Pharaoh as King of Upper Egypt, clubbing a submissive enemy in a composition that now enters the repertoire of dynastic art and persists for the next three millennia. Above the victim a rebus seems to read 'Pharaoh the incarnation of the hawk-god Horus, with his strong right arm leads captive the Marsh-dwellers (Hau Nebut)'. In the lower register two spreadeagled corpses of foreigners are distinguished by glyphs which probably represent the rectangular buttressed fortress of western Palestine and the 'Kite' sanctuaries of Transjordania. This palette is usually regarded as commemorating the victory of the Southern king over the North and the uniting of the two lands under one ruler. Since Narmer appears here as the King of both Upper and Lower Egypt, he has been recognized as the semi-legendary Menes, the first Pharaoh. But as we shall see below, doubt has recently been cast upon this identification.

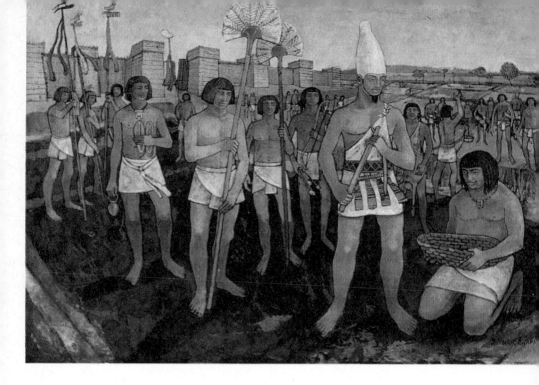

This palette, however, has a rather deeper significance. If it commemorates anything at all, it is the divine might of Narmer himself who dominates the scenes, either as man, hawk or bull. He triumphs over rebellious subjects, as well as the foreigners on the borders of Egypt, over Asiatics, Marsh-dwellers, and Libyans.

The Ascendancy of the Pharaoh

Ills. 36, 37

Precisely the same theme is expressed in rather a different fashion on a votive mace-head belonging to Scorpion, perhaps the immediate predecessor of Narmer, who vigorously expanded the Southern Kingdom. This object, also found at Hierakonpolis, shows the king at an agricultural rite. In the background are the royal standards with, hanging from them, lapwings and bows. In its fully developed form we meet this same idea of the triumphant king as early as a statue-base of Djoser of Dynasty III

36 A reconstruction of the agricultural rite as shown on the Scorpion mace-head (*Ill. 37*). This is a solemn fertility rite to bless the urgent work of cultivation that must begin immediately the Nile recedes, leaving the fertile mud. The king, wearing the White Crown, makes the initial strokes and a high official kneels to receive the first basketful of silt. Behind the king stand members of his court, his fan-bearers, foot-washer and sandal-bearer, armed bodyguard and his priest (or perhaps his eldest son and heir). The king's divine attributes are symbolized by the fetishes carried on poles (*cf. Ill. 32*)

37 The reconstructed mace-head of King Scorpion from Hierakonpolis, *c*. 3225 BC. The king, already appearing of divine size, wears the White Crown and an animal tail and carries a hoe and pick; his symbol, a scorpion, is to the right before his face

where the king is shown treading upon nine bows symbolizing the foreign neighbours of Egypt and being worshipped by docile lapwings representing the populace of Egypt. At this early stage there is no distinction between the people of Egypt and foreigners who are both shown regarding the Pharaoh as their lord and subjugator.

Four great mace-heads of this early type are now known; the Ashmolean example, one in Cairo and two fragments in the Flinders Petrie Collection, University College. It was formerly thought that the two Petrie Collection fragments belonged to the same mace-head. They were published as such by Quibell and Green, and like the other known examples came from Hierakonpolis. Recent examination has shown them to be from two separate mace-heads; one is slightly larger than the other and the second is also somewhat more finished in its polishing. The king is shown seated wearing the Red Crown and holding a flail whilst Horus, the falcon god,

drags captive before him one of the Pig-tailed people who is falling over backwards. Before the king is the faintly preserved hieroglyph for a scorpion, his name. This differs from the Ashmolean mace-head which shows the king performing an agricultural rite wearing the White Crown of Upper Egypt. The Ashmolean and Petrie mace-heads all record conquests, the former over the Plover and Bow peoples as shown above the king's head, and the Petrie fragments the conquest of the highlands to the east.

It would appear, therefore, that King Scorpion already made serious pretensions to rule both Upper and Lower Egypt and to be recognized as a sole monarch among the contiguous nations. Possibly the military conquest may have been largely his work but completed and consolidated by a successor, Narmer, who also laid the political foundations of the Kingship which endured thereafter as long as a Pharaoh wore the Two Crowns. Whether he was the traditional Menes whom the temple-guides told Herodotus was the first King of Egypt, or whether Menes was a conflation of several early conquerors, including Scorpion and Narmer, is still in dispute and must await the discovery of further evidence before the problem can be solved.

In the past there has been perhaps too great a readiness to emphasize the isolation of Egyptian civilization as though it were out of the main-stream of Eastern Mediterranean culture; but it is doubtful whether future research will be able to sustain such an attitude. In more documented times we can see that the Pharaoh exercised a profound influence over adjacent lands. At his accession and jubilees he received Magi-like gifts from foreign ambassadors who begged from him the gift of life that he was supposed to bestow upon their peoples. The early dynastic monuments suggest that this relationship existed from the very first, probably as a legacy of Asiatic contacts in Gerzean times, and perhaps we should not be far

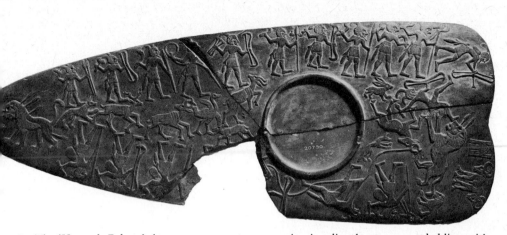

38 The 'Hunter's Palette' shows two groups co-operating in a lion-hunt, a wounded lion with arrows sticking in him is shown at each end of the palette. The hunters wear kilts with animal tails hanging down the back (*cf. Ill. 37*) and carry an assortment of weapons, one even carries a lasso. The leader of each group also carries a fetish on a pole (*cf. Ills. 36, 37*). To the right there is a small shrine and a curious double-headed heraldic bull perhaps symbolizing that the hunt is taking place in the IIIrd nome of the Delta. The eyes of both men and animals are represented by cavities suggesting that the palette is an early example (*cf. Ills. 20, 30*)

wrong in regarding Ancient Egyptian civilization as a specialized branch of a common culture in the Eastern Mediterranean during the Bronze Age.

The size and importance of the king upon these early *Ills. 30, 31* monuments clearly show that he was regarded as a god rather than the human agent of a god, and it is in this that Egypt presents us with a typically African solution to problems of government. Civilizations had arisen in river valleys elsewhere in the Near East and enjoyed economies based on agriculture. They too had unifying systems of communication and knew the art of writing and keeping records. Yet they remained a congeries of rival city-states, each jockeying for an uneasy supremacy, while Egypt displayed a national conformity under the leadership of a deity. For the Pharaoh is the classic example of the god incarnate as king. The concept comes from that layer in Egyptian culture that belongs to Africa where similar rulers still exist. A tangible god whose sole authority could produce results by the exercise of the divine

attributes of 'creative utterance', 'understanding' and 'justice' appealed particularly to the Egyptian psyche, and gave the nation confidence to overcome otherwise daunting obstacles.

The prehistoric rain-maker chieftain who was thought to keep his people, their crops and their cattle, in health and prosperity by exercising a magic power over the weather, is thus transformed into the Pharaoh, able to sustain and protect the nation and having command over the Nile in a rainless land. The never-failing inundations of the river were more predictable in their occurrences, though not in their volume, and therefore more amenable to control than the weather. If the environment in which the Egyptian lived was therefore largely constant and determinable, it is small wonder that his conception of reality should be so essentially static.

It would seem that the organization necessary for undertaking large-scale land reclamation and irrigation could not come into being until the political machinery of centralized rule under a sole king had been devised. Menes was traditionally accredited with the damming of the Nile to control flood-waters. It is probable that the unification of Egypt and the dramatic change it brought about in co-ordinating and accelerating all kinds of communal enterprises, seemed in retrospect miraculous. The kingship and the welfare of the land would then be regarded as indivisible.

The precedents created by Narmer were followed thereafter by his successors, not as a recipe for success but as part of the cosmic order. The tradition was later reinforced by the Osirian myth which taught that an ancient divine king suffered death and dismemberment, but arose from the dead to become king and judge in the Underworld, while his son Horus ruled in his stead on earth. When each Pharaoh, who during his lifetime was regarded as the incarnation of Horus, died and mingled

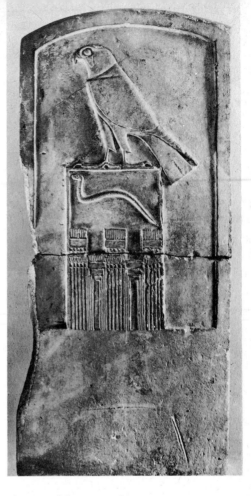

39 A tombstone of King Djet, from his tomb at Abydos, shows the maturity of style attained during the Archaic Period and superb technique. The falcon-god Horus, stands above his 'Horus' name, shown as a serpent with raised head within the 'serekh' – an enclosure representing a palace (*cf. Ills. 60, 89*)

with his ancestors to become Osiris, it was his son, the new Horus, who stood in his place. With each change of king the Egyptian world was created anew in the old pattern which had come down intact from the gods.

Thus Egyptian society was itself like a pyramid, thrusting its gilded capstone into the sky, and we shall find during the Old Kingdom that nearly all the manifestations of culture are concerned with the cult of the living and the dead king on whom the welfare of the people was thought to rest. This is the explanation for the enormous works and the tremendous economic activity which the entire nation undertook for what would otherwise appear as the sole benefit of their rulers.

The Archaic Period—Dynasties I and II

The first unification of Egypt was the work of the tradi-
tional Menes, perhaps Narmer, who recognized the exis-
tence of two Egypts, the North and the South, and made
himself the king of both, thus joining in his own person
two opposing forces. By an act of reorganization rather
than conquest, he produced order out of a warring dual-
ity. The pattern he invented had such a sanctified
authority that his successors never had any inclination to
change it. We can see, for instance, that the perceptual
representation of the human form evident in the relief on
Ills. 32, 34 the Narmer palette – the head, hips and legs shown in
profile, the eye and thorax from the front – was regarded
as adequate thereafter for drawing, painting and relief as
long as Pharaonic art lasted.

But while many of the institutions of kingship remained
frozen at the moment of their creation, not every form of
expression could receive such final utterance in a rapidly
developing world. It was the achievement of the first
four dynasties that they worked out many of the most
valid forms of Pharaonic culture at a time when the whole
of the Near East seems to have been in a kind of ferment
as the different civilizations explored the fuller possibili-
ties of the brave new world of the Bronze Age. The early
dynasties in Egypt give us an impression of a restless

questing spirit tackling problems with assurance and boldly experimenting with new forms to achieve a perfection within each. As soon as a solution had been sanctioned, however, there was no further development; a new convention had been added to the stockpile of *Ills. 61, 103, 109* acceptable traditions.

The Cultural Background

The archaic period covered by the first two dynasties is largely unknown to us. We have the names of kings as listed by Manetho, an Egyptian high priest, who in the reign of Ptolemy Philadelphus wrote in Greek a History of Egypt which now only survives as garbled summaries and extracts in later authors' works. The greatly damaged Palermo Stone preserves the annals of but a few of the kings of this age, and there are also the carefully edited lists of later Pharaohs who, however, recorded their remote ancestors under names that differ from those found on the early monuments. We also have certain archaeological evidence mostly from the plundered tombs or cenotaphs at Abydos and Saqqara which are thought to be of these rulers and their families and retainers. *Ill. 39* Literary remains are almost entirely lacking and those that do exist are difficult to interpret. Nevertheless from a comparison of what precedes and what follows, we can see that the economic and cultural leaven introduced by unification continues unabated. The Residence which Menes had founded at Memphis, the point of balance between Upper and Lower Egypt, remained the centre of this stirring world, and indeed was the metropolis where the arts and sciences flourished throughout the Old Kingdom under the patronage of its creator-god Ptah.

Writing too must have made considerable progress from the ambiguous stammerings of the monumental inscriptions on the slate palettes. A flexible paper manufactured

40 Ptah of Memphis, the creator-god and patron of workmen

41 Wooden tub and striker for measuring corn. From a wall-painting in the tomb chapel of Hesy-re

Ills. 43, 125

42 An inscribed star-sighting instrument made from a date palm rib

from the pith of the papyrus plant is known from the time of Dynasty I at least, and this Egyptian invention must have made the keeping and duplicating of records, memoranda and literary compositions very much easier and more compact. A rapid and cursive form of writing with pen and ink may also be traced back to this period. A convenient instrument for organizing and documenting the work of a centralized state thus existed in Egypt right from the start, and during the Old Kingdom we shall find that officials were proud to have themselves represented as scribes.

As part of this public administration, an elaborate system of taxation appears to have been developed at an early stage. Standard measures of capacity for assessing the amount of the corn harvest, for instance, certainly exist by the time of Dynasty III, when a set of wooden tubs and strikers was painted on the walls of the tomb-chapel of Hesy-re. Linear measure like that of medieval Europe was based upon the human arm, forearm, finger, palm and so forth. The inundation of the Nile yearly erased the petty boundaries between fields and estates so that a system of accurate survey and mensuration had to be devised to re-establish the old limits. While there was thus every stimulus for the Egyptian to develop the science of mathematics his approach to the subject was never more than pragmatic. A decimal system had existed before dynastic times. Later treatises deal with practical mathematical problems which all required to be solved in the building of mastabas (the long, low, rectangular mound with sloping sides built over the tomb of a private person during the Old Kingdom) and pyramids during the first four dynasties, but it was not studied theoretically as an end in itself.

Similar progress in astronomy was stimulated by the necessity of forecasting the annual rise of the Nile. A Ill. 42 sighting instrument for making observations of the stars

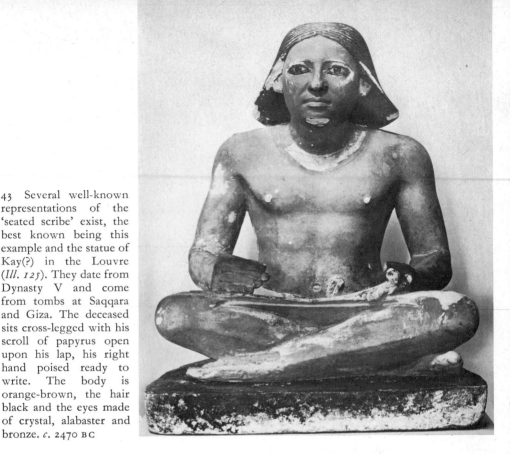

43 Several well-known representations of the 'seated scribe' exist, the best known being this example and the statue of Kay(?) in the Louvre (*Ill. 125*). They date from Dynasty V and come from tombs at Saqqara and Giza. The deceased sits cross-legged with his scroll of papyrus open upon his lap, his right hand poised ready to write. The body is orange-brown, the hair black and the eyes made of crystal, alabaster and bronze. *c.* 2470 BC

was invented during this period and enabled the correct time for the celebration of calendrical feasts to be accurately determined. In an unscientific society the proper moment for the observation of a religious rite was of vital importance. Astronomy was also employed in providing fixed points by which buildings could be properly aligned according to ideas of dogma. Much of this science flourished at Heliopolis, the centre of a sun-cult, the ritual of which was largely concerned with time-measurement and the study of the sky and the movement of heavenly bodies. The accurate orientation of pyramids and their geometrical precision may have owed much to the influence of architects of Heliopolitan origin. It was during this period that the old agricultural lunar calendar which had existed in Egypt since Predynastic days was

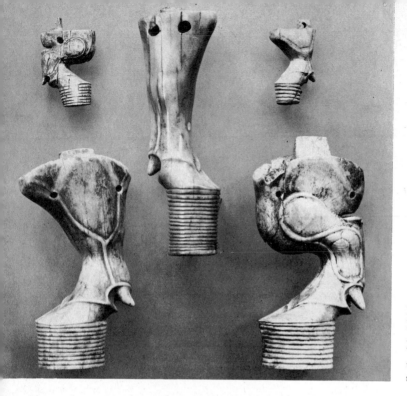

44 Ivory chair legs in the form of bull's legs from the Dynasty I royal tombs at Abydos (*cf. Ill. 102*). The bull hoof changes to a lion paw in later specimens of furniture

supplemented for secular purposes by the introduction of a more accurate calendar based upon twelve months, each of thirty days with five extra feast days, though this system too had to be further improved a little later by the use of a third calendar.

The Material Culture

Ill. 44

Ills. 45–47

The material remains from the greatly devastated sites at Abydos and Saqqara give tantalizing glimpses of a culture at once primitive and sophisticated, traditional and experimental. We can see that such crafts as the manufacture of stone vessels continued in vigour, exploiting natural formations in banded stones, and even developing a daring virtuosity. Pottery on the other hand declined in artistry and settled down to a drab utility. The introduction of the potter's wheel at the beginning of the period probably hastened the process. In contrast, copper working shows a rich development. Very many tools, weapons, and ingots

45 A slate toilet dish of the Early Dynastic Period. The dish is made up of two hieroglyphs, the central portion and handle the *ankh*, sign of life; and the outer edge formed by two upraised arms, the *ka* sign for spirit, food

46 Carved from a solid block of schist, a rock which splits in thin irregular plates, this remarkable dish possibly imitates a form originally made in metal. It was found in the tomb of Sabu at Saqqara and dates from *c.* 3100 BC

47 A slate dish which reflects in its form and design a basket archetype: it is inscribed with the sign for 'gold' and came from the Step Pyramid of King Djoser

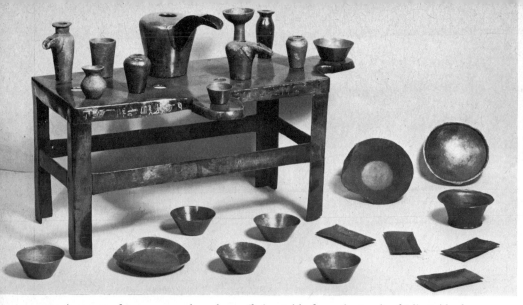

48 A group of copper vessels and an offering table from the tomb of Idi at Abydos, *c.* 2300
BC. The spouts of the libation vessels were made separately and then attached to the body of
the vessel by hammering in a tradition of copper-working that existed from the earliest dynasties
as evidenced by the finds from Abydos and Saqqara

Ill. 48

of copper have been found in an important tomb of
Dynasty I; and also from this same deposit came scores
of bowls, ewers, and vases raised by hammering sheets of
copper. These are the ancestors of a long line of such
metal vessels in Egypt. Besides hammering, both hot and
cold, to obtain the required shape, moulding was also
practised. Both methods were used to produce tools. The
lighter tools such as saw blades and knives were cold
hammered after the material had first been roughly cast
to the required shape. Larger and heavier tools such
as axes and hoe-blades were roughly cast and hammered
into shape whilst still hot. The sharp edges particularly
required on the copper cutting tools would probably have
been obtained by hammering, and it has often been noted
that this process has a tendency to make the tool rather
brittle if carried too far. The eye-holes of needles and the
teeth of saw-blades were punched out, but the problem
remains as to how this was achieved or the material that

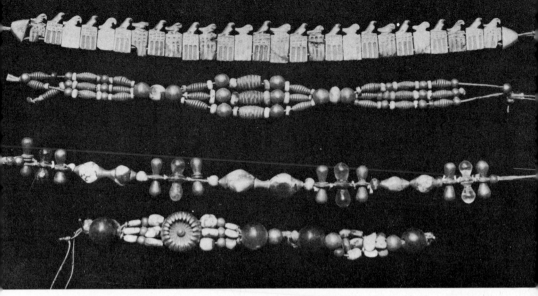

49 Four bracelets found on a linen-wrapped arm in the tomb of Djer(?) at Abydos. Three are composed of multi-coloured beads of turquoise, dark blue lapis-lazuli and amethyst. The fourth is made of small faience plaques of 'serekh', or 'palace-façade', form surmounted by a Horus falcon. Compare with *Ills. 39, 56, 59 and 60. c.* 3100 BC

was used. A harder metal would be needed to make the punch, but the method of manufacturing bronze was as yet unknown.

Probably most copper implements were used with quartz sand, and when once the grains had become embedded in the softer metal an almost diamond-hard edge would be put on the cutting surfaces. Copper saws were certainly used with such an abrasive for cutting hard stones during the Pyramid Age. Flint tools, too, continued to be used alongside copper examples.

From the end of the Old Kingdom have survived two greatly corroded statues of Pepy I and his son made by hammering copper plates over a wooden core, which seem to be in a tradition that goes back to the beginning of the period, since an inscription exists mentioning copper statues made by a king of Dynasty II. It is clear that the goldsmith and jeweller did not lag behind in the techniques of working gold and electrum but unhappily

Ill. 120

59

Ill. 49

very little of these precious metals has escaped the clutches of the tomb robber and we have practically no representative material from this period. Four bracelets were found by Petrie on an arm wrapped in linen and stuffed into a crevice in the tomb of King Djer at Abydos. The ancient tomb-robber, disturbed at his ghoulish work, must have hidden it in the crevice and failed to return for it. The bracelets are of exquisite workmanship and made of gold, turquoise, dark blue lapis-lazuli and amethyst respectively and perhaps belonged to a queen of King Djer. Three of them consist of the typical multi-coloured beadwork much in evidence in later periods, but the fourth was composed of small 'palace-façade' plaques, each surmounted by the Horus falcon. Small ivory labels were found in the tomb of Queen Neithhotep at Naqada and appear to have been attached to the boxes containing the bead necklaces buried with the queen. The labels are dockets which record, beneath a picture of the necklace, the numbers of beads on each string. It is highly probable that great quantities of goldwork existed in the tombs of the First and Second Dynasties at Abydos and Saqqara. There is evidence particularly from the latter site of wood encased pilasters which had been overlaid with thin sheets of embossed gold set approximately one centimetre apart.

The owner of a private tomb of Dynasty I at Naga-ed-Der was buried with a rich parure, including a gold circlet, gold beads shaped as snail shells and gold amulets in the form of an oryx and a bull.

The fragments of worked wood and ivory that have been recovered from the tombs of Dynasty I reveal that the joiner was disposed to copy faithfully decorative forms that belonged to work in rush or basketry. The carving is highly accomplished with that unmatched technical proficiency of the Egyptian craftsman at his best. A compartmented box from the same source, however, displays a full appreciation of the functional possibilities of

Ill. 50

Ill. 51

60

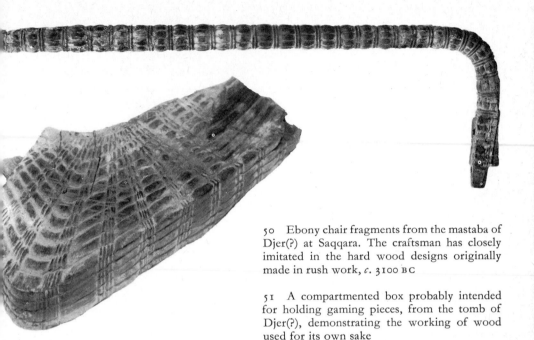

50 Ebony chair fragments from the mastaba of Djer(?) at Saqqara. The craftsman has closely imitated in the hard wood designs originally made in rush work, *c.* 3100 BC

51 A compartmented box probably intended for holding gaming pieces, from the tomb of Djer(?), demonstrating the working of wood used for its own sake

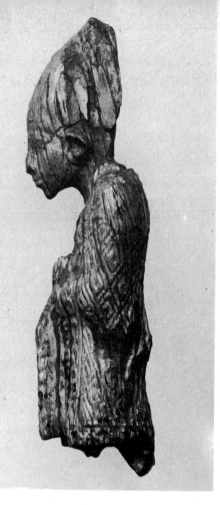

52 This small ivory statuette from Abydos shows the king, an unknown Pharaoh, striding forward in a ritual involved in the *heb-sed*, or jubilee, ceremonies. He wears the tall White Crown and a cloak patterned with lozenges wrapped around him. *c.* 3000 B C. Cf. *Ill. 103*

Ill. 52

Ill. 53

construction in wood. Ivory carries on an inheritance from prehistoric times, though only the figurine of a king wrapped in his Jubilee robe as he strides forward in a pacing ceremony is complete enough to give a full idea of its quality. Among these scanty remains particular mention must be made of an object from a game which has survived almost in its pristine condition. It consists of a black steatite disk carved in low relief on one side with the figures of two hounds attacking two gazelles, both of which are formed from pieces of pink alabaster let into the surface, as is one of the dogs. Not only does this disk show in its fine drawing and craftsmanship all the features

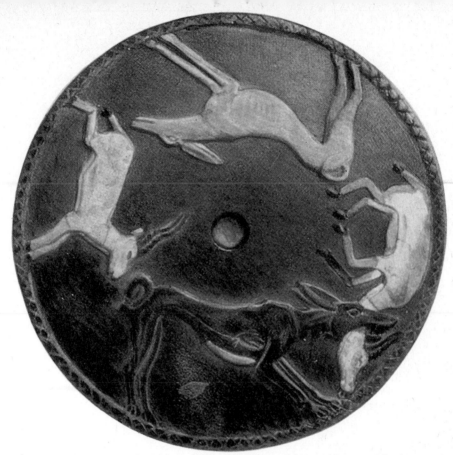

53. A black steatite disk carved in low relief, probably used in a table game. It shows two hunting dogs attacking two gazelles, both of which are made from pink alabaster let into the surface as is also one of the dogs

of the best later relief sculpture, but the way in which the artist has disposed the elements in his design, arranging the animals so as to square the circle, reveals a fundamental feature of all dynastic art in Egypt – a feeling for space defined within strict rectangular or cubic outlines.

All this is in marked contrast to the malformed signs and inept carving of the inscriptions on contemporary ebony and ivory labels, probably because these were from the hands of maladroit scribes better at wielding a pen than a chisel. Two literary works surviving in versions of a later period are thought from internal evidence to date to Dynasty I. One of these is a treatise upon surgery,

Ills. 54, 55

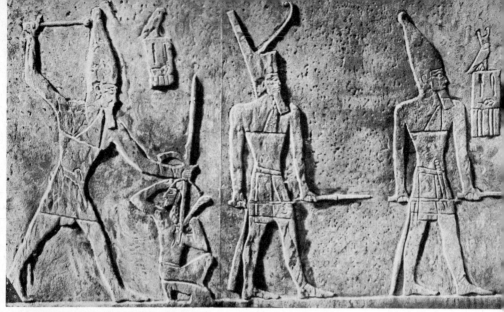

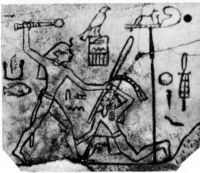

54 A rock-carving in the Wadi Maghara showing Sekhem-khet slaying enemies in a ritual pose that appears early in Egyptian art (*cf. Ills. 34, 55*)

55 An ivory label of King Den (*c.* 3000 BC) for attaching to a pair of sandals. The king is shown smiting Bedouin and the inscription reads, 'First time of smiting the East', and was a primitive method of identifying a year for dating purposes

especially upon fractures, which is remarkable for its empirical approach to the subject. The other is a work on theology, ascribing the creation of the universe to Ptah of Memphis, in which an entirely unusual search for first principles is evident. Some scholars have been inclined therefore to detect at this period of extreme activity in so many fields of endeavour, a novel if tentative groping towards a scientific attitude on the part of the Egyptian to the universe around him. It is, however, so hesitant as to be barely perceptible and the approach once made is soon abandoned and never afterwards followed.

Architecture of the Old Kingdom
Dynasties III–VI

The promise of the first two dynasties was achieved in the next two. In the absence of nearly all historical and literary documents, we are obliged to assess the achievement of the civilization of the Old Kingdom from the funerary monuments around the great sites near Memphis – the architecture and sculpture that have survived in a ruinous condition at the cemeteries near Giza, Saqqara, Abusir and Dahshur.

There must have been in the prehistoric age unknown geniuses of the order of a Newton or an Einstein, whose thought and imagination reached out beyond their time and transformed the life of mankind. We are fortunate, however, in knowing a little about one of the earliest of such men in historic times, Imhotep, trained in the learning of Heliopolis, the Chancellor of Djoser, an early king of Dynasty III. In later ages Imhotep was celebrated as an architect, astronomer, priest, writer and sage, and above all, as a physician, being eventually deified as the god of medicine. His greatest memorial, however, is the funerary monument that he erected for Djoser at Saqqara, to which the name of the Step Pyramid or Step Mastaba is now given.

Ill. 56

Ill. 57

Ills. 58–60

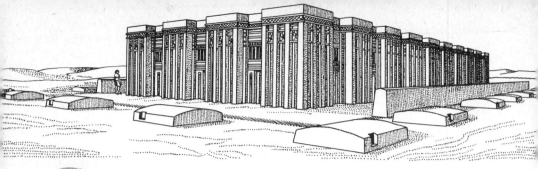

56 Reconstruction of the superstructure of a royal tomb at Saqqara, probably that of Queen Merneith. Archaic Period, Dynasty I, *c.* 3100 BC

57, 58 The architect of the Step Pyramid and Chancellor of Djoser, Imhotep was revered in the Late Period as a sage and patron god of medicine. He is often shown, as in this late bronze statuette, seated with an open scroll on his knees. The inscription around the base records the name of the person who dedicated the statuette. Imhotep's architectural masterpiece, the Step Pyramid at Saqqara, is seen in the aerial view (*Ill. 58*) from the south-east. The remains of the temenos wall surrounding the sacred area are evident and also the 'dummy' chapels in the foreground

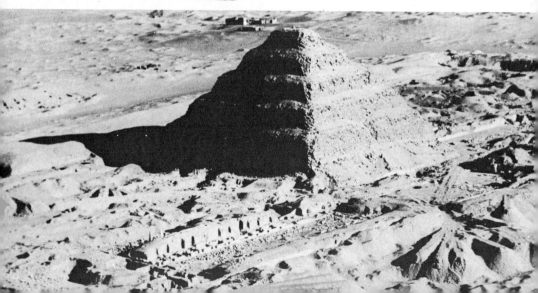

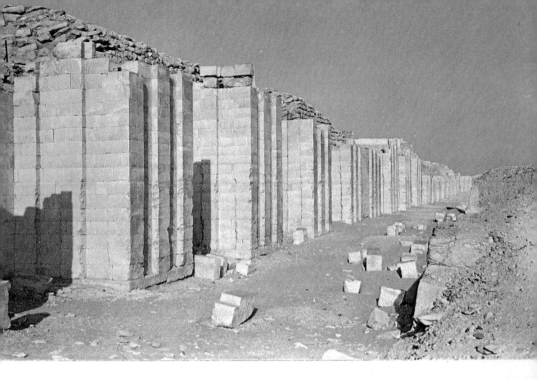

59, 60 The temenos or girdle wall of the Step Pyramid (*Ill. 59*) is composed of numerous bastions making an articulated façade. Although there are fourteen gateways in it, only one is an actual entry. The reconstruction (*Ill. 60*) shows it as it would have appeared from the south-east, c. 2680 BC, standing outside the temenos wall with its panelled façade. The single true entrance is to the left. The other thirteen entrances are dummy portals

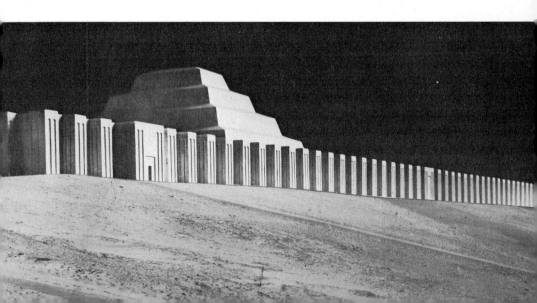

Building in early dynastic times had progressed beyond the mud hovels and reed shelters of prehistoric days, though these were still in use among the peasantry. The introduction of mud-brick and massive structural timber imported from the Lebanon encouraged a change in the type and size of the more important buildings such as palaces and temples, though many decorative features derived from building in flimsy vegetable materials plastered with mud were copied in the new medium. This was the architecture of the living which was also employed for the superstructure of the 'houses of eternity' of the dead. The development of architecture during the early Old Kingdom is largely concerned with the search for more permanent materials, wood and mud-brick replacing lashed bundles of papyrus stalks, rush matwork, palm-thatch and wattle and daub. Stone begins to be used for parts of the house subjected to hard wear such as lintels, thresholds and door-posts; but the next step of building entirely in stone was never taken for the living, even the most exalted, but for the dead. The urge towards a monumental conception of architecture arose from the need to house the dead king in a tomb that would last for ever. While there is an inscriptional reference to a stone temple in the reign of Djoser's father, the art of building in stone was traditionally accredited to Imhotep.

The Saqqara and Dahshur Pyramids

Ill. 58

The actual tomb of Djoser was in a maze of galleries beneath a stone erection consisting of six superimposed rectangular stages with sloping sides diminishing in size as they reach skywards to a height of over two hundred feet. This stepped pyramid dominates a complex of buildings surrounded by a massive bastioned enclosure wall with a perimeter of over a mile, and a height of more than

Ills. 59, 60

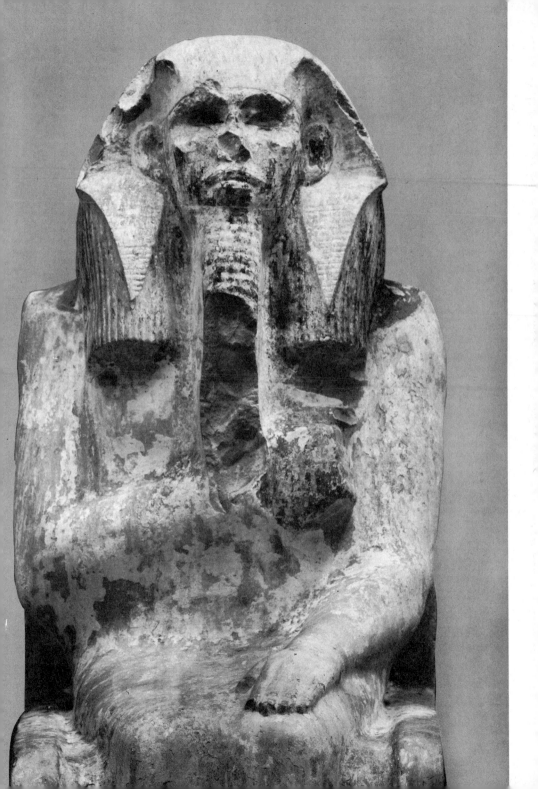

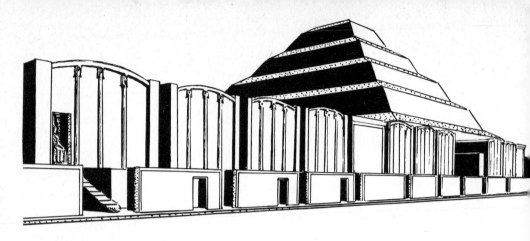

62–64 A reconstructed view of the Jubilee Court within the temenos walls of Djoser's pyramid complex. The chapels consist merely of façades with a rubble backing. A number of statues of Djoser were left unfinished in the Jubilee Court (*Ill. 63*). They show the way in which the figure was first mauled out in rough outline before the final dressing and polishing. The king wears a heavy wig and it seems from the projection above the head that this statue was intended to be engaged in a wall. The Antiquities Service, under the direction of J-Ph. Lauer, has been engaged for a number of years in excavating and partially restoring this area. The façade of one of the chapels in the Jubilee Court has here been completely rebuilt, mostly from the fallen remains. The backing to the façade is, as originally, packed rubble

65 A statue of the deceased was walled up in a small chapel (*serdab*) with two small eye-holes ▷ before the face so that he could look into the room before him where offerings were laid. Here the statue of Djoser (*Ill. 61*) gazes out through one of the eye-holes, from the darkened enclosed area which no mortal in the time of the king would have seen from this viewpoint

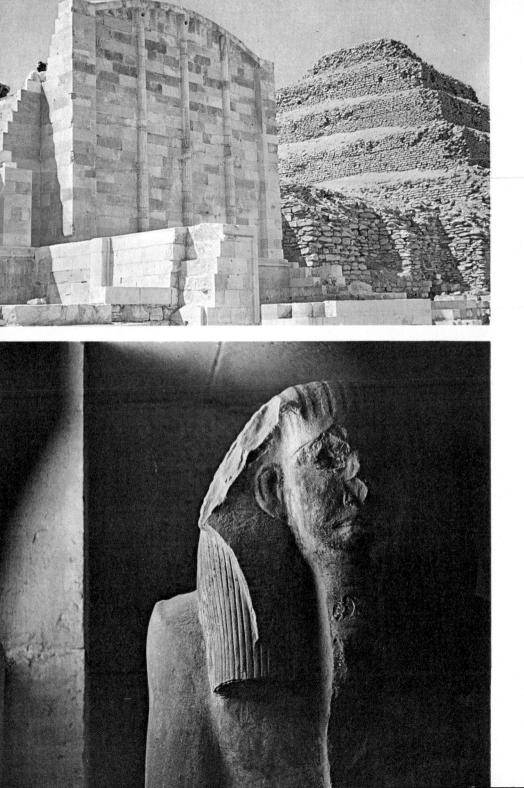

66 An imitation in stone of a stake fence, barring access to the sanctuary buildings of Djoser at Saqqara

Ills. 62–64

Ills. 61, 65

Ill. 66

thirty-three feet. Within this vast compound were courts and edifices which were presumably modelled upon those used by Djoser during this lifetime. Apart from a mortuary temple and *serdab* (a kind of oubliette from which a statue of the deceased could look out on to the offerings in the offering-chamber of his tomb) containing a statue of the dead king, these buildings are in duplicate and simulate light structures used at coronation and jubilee ceremonies when the king performed every rite once as ruler of Upper Egypt with appropriate insignia in a characteristic Upper Egyptian shrine, and again as king of Lower Egypt in different dress and surroundings. It is a unique feature of these mortuary buildings, however, that they serve their purpose by magic, not actuality. Most of them present a mere façade in front of a solid rubble core. Of the fourteen great gateways that interrupt the rhythm of the bastions on the enclosure wall, only one is a true entrance. Similarly, stone imitations of wooden doors standing open were carved where approach was permitted: at other points representations of stake fences barred access. The dummy nature of many structural features rather encourages the view that the architect and masons were feeling their way in an entirely new medium. The quarrying and handling of large stones had

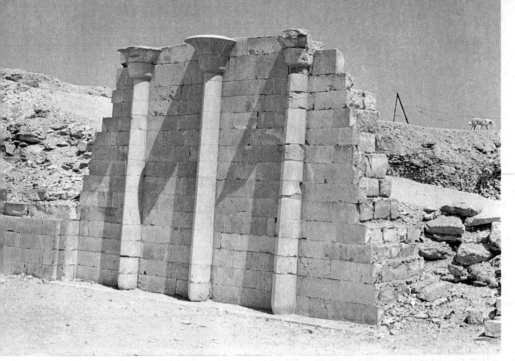

67 The architect and masons working in the unfamiliar medium of stone instead of mud-plastered reeds at Saqqara were unwilling to commit themselves completely to free-standing columns. These columns on the east side of the northern court are only half-columns since they are engaged into the wall behind them

not been perfected and the small-block masonry shows a translation into more permanent material of construction proper to mud-brick and vegetable products. This, the elegant proportions and the emphatic carving of plant forms such as papyrus stalks, pendant leaf capitals and fasciculated columns lend an air of naturalism and vitality to the buildings which is rather in conflict with their mortuary purposes.

Ill. 67

Nevertheless, at the time of its completion, this monument must have been the wonder of the age, as indeed it remained for subsequent generations in Egypt. Nothing like it had appeared on earth before. It enshrined within its chambers a mass of objects almost as novel as itself, wall panels decorated in blue-glazed tiles in imitation of the coloured reed mats hung on interiors, large statues of

Ill. 69

68 In this relief from the South Tomb Djoser is showing running on a ceremonial course
connected with the celebration of the Jubilee festival. He wears the White Crown and carries the
'flail' in one hand and a leather 'portfolio' in the other. Above him hovers the falcon of Horus
of Edfu, holding the *ankh*, symbol of life; before his face is written his 'Horus' name, Netjerikhet
which is under the protection of Horus wearing the combined Red and White Crowns. The
relief is set in a niche within a border of faience tiles (*cf. Ill. 69*)

Ill. 68

Ill. 47

the king in seated and standing poses, stelae in delicate low relief in which the athletic figure of Djoser performing the ritual of some eternal jubilee is accompanied by hieroglyphic inscriptions of coherent assurance, the coffin of an infant made in six-ply wood, and the tens of thousands of handsome vessels in alabaster, breccia, rock crystal, serpentine and 'every costly stone'. All this treasure was in addition to that greater store that must have been plundered from it long ago. The Egyptian peasant pausing from his muddy labour in the Saqqara fields to look up at it could never know what lay behind its single entrance port, but the sight of that vast monument standing white, mysterious and silent upon the skyline must have convinced him that he was ruled by veritable gods.

The style set by Djoser's Step Pyramid was evidently copied by his immediate successors who, however, were unable to finish their undertakings. But the recently discovered complex of King Sekhem-khet near by already shows a more massive form of building using large stone blocks without reference to mud-brick.

This pyramid to the south-west of Djoser's was unfinished at the time of the king's death; he probably did not reign for more than six years and much of the projected complex of temples and shrines was left unfinished. From measurements of the uncompleted base, about 395 feet square, and of the lowest and part of the remaining second step it would appear that originally the pyramid was planned to rise in seven steps to a height of about 230 feet. This would have given it one step more

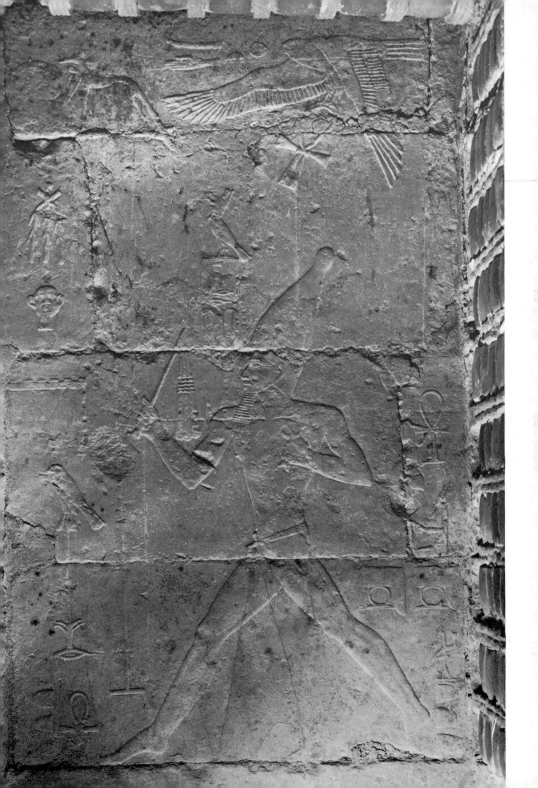

than the Step Pyramid and it would also have been some 26 feet higher than Djoser's monument. The temenos wall surrounding the pyramid and its attendant buildings was roughly the same as Djoser's in length, but only two-thirds as wide (approximately 550 × 200 yards). The pyramid being unfinished, some interesting constructional features were left when work was discontinued. Ramps which practically covered the monument were found *in situ*, but it is uncertain whether they were used by the actual builders, or by later desecrators who exploited the place as a quarry, or by both. At intervals in the rubble which made up the ramps a crude pavement was found composed of flat, roughly hewn stones. As the stages of the pyramid rose, the construction ramps would have been lengthened and risen with it. The building material was brought up by the main supply ramp which lay to the west. In the partly subterranean corridor giving access to the galleries under the pyramid, the excavator, the late Zakaria Goneim, found a deposit of stone and pottery vessels and some mud sealings impressed with the name of the then unknown Sekhem-khet, as well as a cache of jewellery of Dynasty III date. This included twenty-one gold bracelets of varying sizes, a pair of electrum tweezers, a gold necklace and a small gold box which had a lid shaped as a cockle-shell. In an adjacent

Ill. 70

chamber Goneim found a sarcophagus made from a single block of alabaster with a sliding panel at one end instead of the more usual lid. When this panel was raised, the interior was found to be empty, a circumstance which convinced Goneim that the tomb was a cenotaph and the true burial of the king lay elsewhere under the pyramid, or in its environs. M. J.-Ph. Lauer, however, has recently given good grounds for believing that the coffin inside the sarcophagus was removed by ancient robbers and the vegetable remains found on the upper surface of the sarcophagus are not a greatly decayed funerary wreath,

69 Nearly every ritual building within the vast complex of the Step Pyramid was duplicated. In the so-called South Tomb blue-glazed tiles imitated the coloured reed matting that had adorned the walls of the king's palace during his lifetime

70 The alabaster sarcophagus of Sekhem-khet standing isolated in the burial chamber beneath the unfinished pyramid. The remarkable sliding trap door which sealed it is half raised and the remains of wood bark and a wooden lever lie on the top. *c.* 2670 BC

but a wooden lever used by the thieves in their operations. Further research may reveal whether the burial was of King Sekhem-khet or a near relative.

Lauer, himself, in the season of 1962–3, made soundings on the site and found the greatly ruined sub-structure of a building similar to the Southern Tomb in the Step Pyramid of Djoser, as well as other architectural features, but insufficient funds were at his disposal for a proper clearance of the monument.

Ill. 76

This megalithic type of construction begun under the two kings, Djoser and Sekhem-khet, of Dynasty III was exploited by their successors, particularly the kings of the next dynasty. They evolved at Dahshur, Maidum and Giza funerary monuments in the form of a stone pyramid, doubtless under the increasing influence of Heliopolis and its priests where a pyramidical stone was of great significance in the cult of the sun-god Re. At both the former sites, Dahshur and Maidum, unusual shapes appeared amongst the pyramids erected.

71–73 The Pyramid of Maidum, *c.* 2630 BC, apparently stands upon a conical hill (*Ill. 71*), this is made up mainly of debris, which has been formed by the destruction of the outer casing of the pyramid in antiquity (*cf. Ill. 76* B). The small well-preserved mortuary chapel (*Ills. 72, 73*) was buried very deeply in the rubble before excavation (*Ill. 71*). Built entirely of Tura limestone it is approximately 34 feet square and has a maximum height of 9 feet. The door in the south side (*Ills. 72, 73*) opens into a passage at right angles to it behind which is a parallel chamber. An open court behind backs directly on to the pyramid (*Ill. 71*) in the middle of which stands a low limestone altar flanked by two tall monolithic limestone slabs with rounded tops standing on low rectangular plinths. Neither of the slabs is inscribed and this together with the fact that the lowest courses of the temple walls are unfinished, would seem to indicate that the work was never completed. The slabs were obviously designed as funerary stelae and would have been inscribed with the king's names and titles

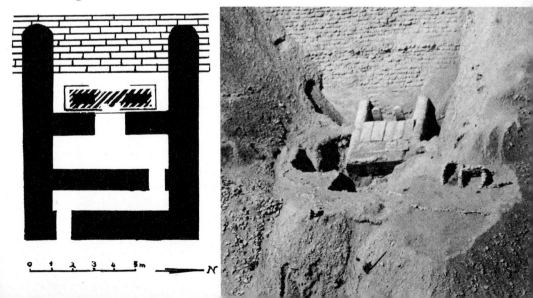

74 The Bent Pyramid of Dahshur, *c.* 2600 BC, standing on the edge of the desert plateau, from the east. Instead of continuing the angle of slope of 54 degrees at the base of the pyramid upwards to the apex there is a sudden change to an angle of 42 degrees. It has been suggested that this was due to the pyramid having to be finished in a hurry. The original Tura limestone casing is the best preserved of all the pyramids

Ill. 74

Ills. 71–73

It is known from inscriptions of Old Kingdom date that Sneferu of Dynasty IV had two pyramids. One now definitely ascribed to him is the so-called 'Bent' Pyramid at Dahshur from the testimony of inscriptions and stelae found in the surrounding buildings. Evidence also exists to show that this pyramid is the one known from inscriptions as the 'Southern Pyramid of Sneferu'. In addition, Sneferu had a Northern Pyramid which would, by inference, appear to be the true pyramid lying approximately a mile to the north. It has been suggested by scholars that Sneferu also built the pyramid at Maidum which lies to the south of the Bent Pyramid at Dahshur. Although this possibility has to be accepted, there is another alternative. The pyramid at Maidum has often been ascribed to Huny, a somewhat obscure predecessor of Sneferu, and one explanation offered for the similarity of building techniques in all three monuments is that Sneferu finished his predecessor's monument on a larger scale. The present appearance of the pyramid is rather strange since it seems

75 The corbelled roof of the lower chamber of the Bent Pyramid at Dahshur (*cf. Ill. 76* C, D). Each succeeding masonry course is edged forward above its predecessor until only a small gap remains to be bridged in the roof of the chamber. High up in the roof on the left-hand side a narrow passage leads to the burial chamber in the heart of the pyramid at ground-level

to stand on a conical hill, which, however, has been formed by the fall of debris from the upper part of the structure following on the destruction of the casing in antiquity. It is hoped that many problems of Dynasty IV architecture will be solved when this debris has been removed, and the surrounding area properly excavated. No doubt the builder's name will also be ascertained. It was in a tomb close to this pyramid that the famous statues of Prince Re-hotep and his wife, the Princess Nofret, were found by Mariette.

Ill. 105

The Northern Pyramid at Dahshur is the first true pyramid with its slope rising at a gentle angle of 43° 36′

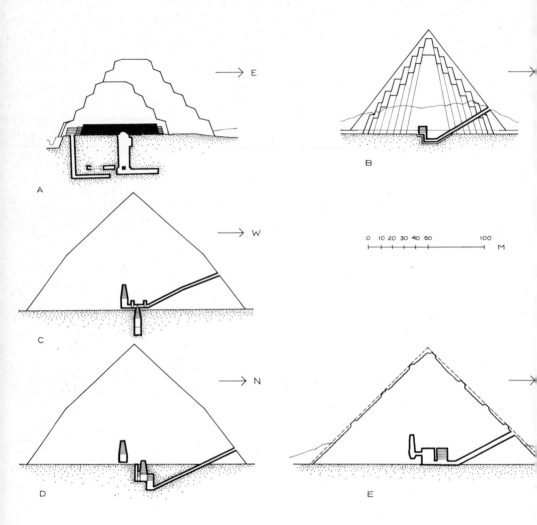

76 Sections of some of the principal pyramids of Dynasties III and IV drawn to the same scale. A. The Step Pyramid of Djoser, Saqqara; B. The Maidum Pyramid of Huny(?); C. and D. The Bent Pyramid of Sneferu, Dahshur; E. The Northern Pyramid of Sneferu, Dahshur; F. The Great Pyramid of Kheops, Giza; G. The Pyramid of Khephren, Giza; H. The Pyramid of

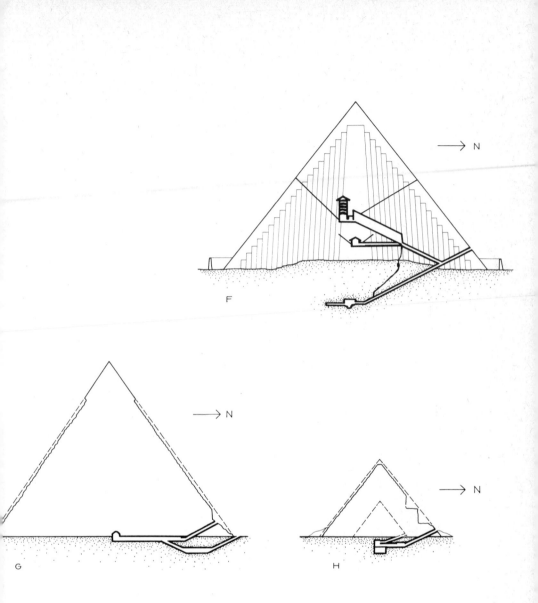

Mykerinus, Giza. The Pharaohs of the Old Kingdom also built pyramids at Abu-Rawash and Abusir (*cf. Ills. 90–93*). The majority of these structures are completely ruined and some are unfinished and do not present the majestic appearance associated with those here illustrated. In many instances their ascription to individual Pharaohs within the Old Kingdom is debatable

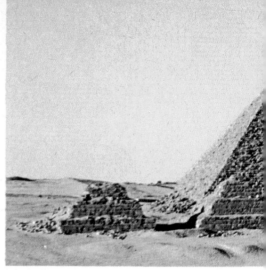

77 The Pyramids of Giza from the south-east. In front of the smallest of the three, that of Mykerinus, are the small pyramids of three of his queens. The central pyramid, Khephren's, looks larger than the Great Pyramid, to the right, because it stands on slightly higher ground. Originally it was some 10 feet lower than Kheops' pyramid although in their present damaged state it is only 2½ feet lower

instead of 52°, which was to become the normal angle of ascent of later pyramids. Mastaba tombs in the area were occupied by courtiers of Sneferu and an inscription said to have been found nearby dated to year twenty-one of the reign of Pepy I records the exemption of the 'Two Pyramids of Sneferu' from specified payments of taxes. A reasonable case is therefore apparent for this being the Northern Pyramid of Sneferu.

Ill. 74

The Bent Pyramid, i.e. the Southern Pyramid, is unique not only in its shape but also in having two separate entrances, one situated roughly in the middle of the north face, about 40 feet above the ground; the other, some 45 feet south of the middle of the west face. This latter entry is the only known exception to the rule that all Old Kingdom passages of this type should run from the north. Each entry led to a separate chamber; the north to a subterranean rock-cut chamber, the west to a chamber at ground-level and slightly to the south-east above the other. A narrow passage running from a point high up

Ill. 75

in the corbelled roof of the subterranean chamber connects with its fellow at ground-level.

The problems concerning the three pyramids at these two sites of Dahshur and Maidum are not insurmountable, but a great deal of work remains to be done before the solutions can be offered.

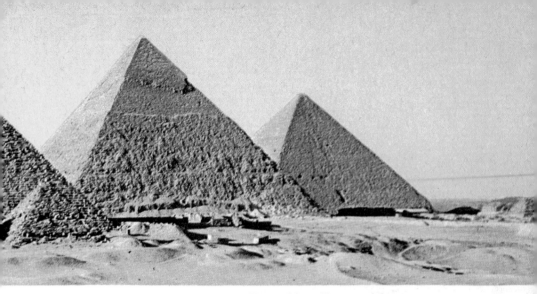

The Giza Pyramids

The climax of this development came early with the building of the Great Pyramid of King Kheops (Khufu) at Giza. The vizier Hemon, a cousin of Kheops, was the King's Master of Works and evidently responsible for this mighty monument built to an astonishing degree of accuracy by the simplest of means. The impressive statue of Hemon, from his tomb at Giza, gives a brilliant portrait of this resourceful architect and engineer.

Ill. 77

Ill. 80

The construction of the pyramid took well over two million large blocks of limestone, some of them weighing as much as fifteen tons. The stone for the core was hewn on the spot, but the facing blocks were of finer limestone and quarried at Tura across the river. There have been many suggestions as to how the pyramids were built. The most plausible has recently been made by the American scholar Dows Dunham as a result of excavations in which he assisted at Giza. He has postulated that four rubble and mud ramps starting at each corner of the pyramid base were built on the undressed outer surface of the casing-stones and extended at the upper end as the pyramid rose course by course. Three of the ramps were used for hauling blocks and other materials to the course under construction: the fourth was reserved for men

Ill. 78

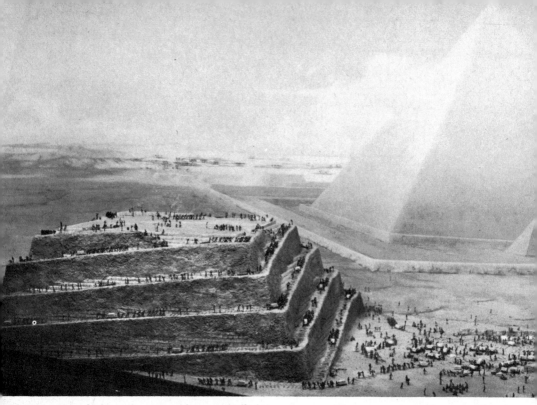

78 Exactly how the pyramids were built is not known. The most acceptable suggestion is illustrated in this model of the building of the smaller pyramid of Mykerinus. Four rubble and mud-brick ramps were built, one starting from each corner, against the undressed outer surface of the casing stones. Each was extended as the pyramid rose in height. Stones were dragged up three of them on sledges, the men descending via the fourth. Once the capstone was in place the outer casing would be smoothed downwards as the ramps were removed

descending with empty sledges. Dunham's calculation is that 2,500 workmen only could have operated effectively at the working face, and in the later stages of the building doubtless even fewer could have been accommodated. Many more men would have been employed in the quarries and in transport work, but he considers that the figure of 100,000 supplied to the Greek traveller Herodotus by the interpreters of the day, is a gross exaggeration. Petrie has also pointed out that organization of labour would be more important than mere numbers of workmen, and it is probable that while the task of quarrying, assembling and fitting the blocks occupied skilled

79 This early engraving shows the great height of the Grand Gallery in the Great Pyramid. In the extra space provided by the high ceiling (28 feet high) the great granite blocks that were used to seal the Ascending Corridor were stored until after the burial when they were lowered into the corridor. The workmen, sealed within the pyramid behind the blocks, made their escape through a narrow passage running from the base of the Grand Gallery into the Descending Corridor (cf. Ill. 76 F)

craftsmen continuously, the labour of hauling the stone into position was seasonal, being performed by field labourers thrown out of work by the Nile inundation. A fact not generally realized, but discovered by Petrie in his survey of the Great Pyramid, is that the king's sarcophagus, made of granite and now lidless, was actually built-in during the construction of the pyramid. It must have been placed in position at the west end of the burial chamber before the masonry courses had risen high enough for the roof to be added and so seal the chamber except for the low entry passage. This is proved by the fact that the sarcophagus is approximately one inch wider than the Ascending Corridor, the main approach to the burial chamber. The king was probably laid within the sarcophagus in an inner coffin of wood, of which nothing survives.

When the capstone of the pyramid had been put into place the work of smoothing the rough casing-blocks would proceed as the ramps were removed. Around the pyramid proper was built a girdle wall enclosing subsidiary buildings, including the mortuary temple connected by a causeway to a temple near the limits of the Nile.

During the Old Kingdom it was the practice to bury funerary boats alongside the tomb or burial monument. A number of empty boat-shaped pits occur at Giza in the vicinity of the Great Pyramid and the smaller mastaba tombs of the queens near by. Recently at Saqqara, Emery found an example of such a boat buried alongside the mastaba ascribed to Djet of Dynasty I. During the course

Ill. 81

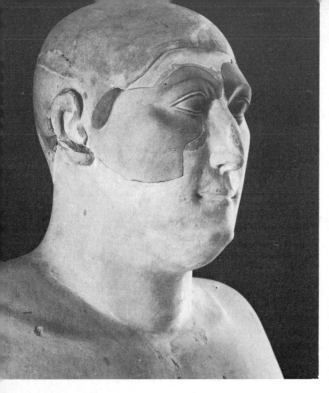

80 The statue of the vizier Hemon, *c.* 2580 BC the architect of Kheops who probably built the Great Pyramid, shows his strong personality and resourcefulness. It is an unpainted limestone, with an inscription inlaid with coloured pastes. The inlaid eyes, gouged out by tomb robbers, have been replaced in plaster

81 Boat-pits and mastaba tombs of the queens to the east of the Great Pyramid at Giza. The pits are boat-shaped and, although insignificant from above, their size may be judged by the native on a camel on the road in the foreground

82 The empty black granite sarcophagus of Kheops stands at the west end of the burial chamber in the heart of the Great Pyramid (*cf. Ill. 76* F). One corner has been broken away, the lid is missing and its appearance is very rough. Many of the marks made by the saws in cutting the stone are still clearly visible

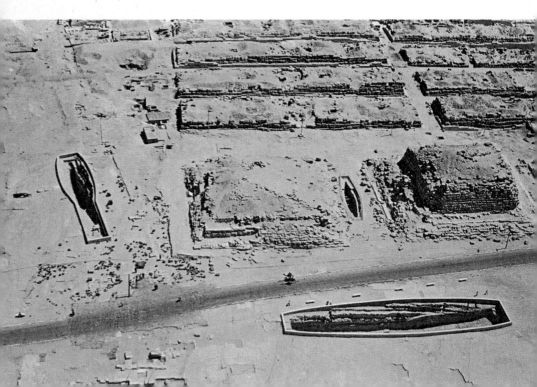

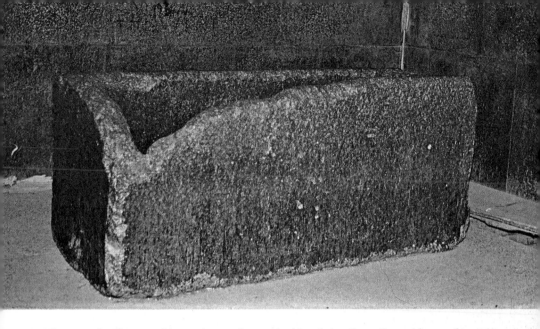

83 The recently discovered boat-pits on the south side of the Great Pyramid seen from the top of the pyramid. The long shed against the pyramid face is where the cedar-wood boat is at present being restored. Beyond it can be seen the oblong pit, not boat-shaped as in *Ill. 81*, where it was found. Also visible is the rabbeted edge of the pit into which the limestone sealing blocks were let, making the pit air-tight and so preserving the boat. To the right the blocks which seal what is probably a second boat-pit are visible

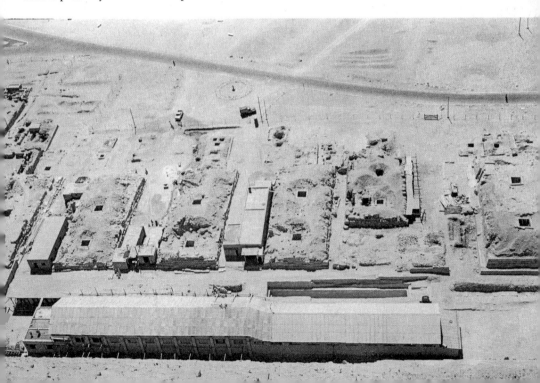

Ill. 83

of excavations in 1954 to remove a large mound of debris and sand against the south side of the Great Pyramid and to make a new road, a long sealed pit was found. The pit was closed by large limestone blocks and had been hermetically sealed by the plaster in which the blocks were set. When opened, an intact cedar-wood boat was found, the oldest of any boat of large size as yet found. Until this discovery the oldest specimens were three boats of Dynasty XII unearthed at Dahshur.

The Kheops boat had been partly dismantled when it was buried since the pit was only some 93 feet long and the boat as reassembled measured 143 feet in length. A large cabin was placed slightly aft of amidships on the deck, the roof being supported by palmiform columns and there were high prow and stern posts. Scattered over the deck were many dismantled parts, the bow-post, rowing oars, the large steering oars, coils of rope and the poles for a canopy. Originally a canopy was spread over the cabin, and a small space left between it and the outer wall of the cabin acted as a primitive form of air conditioning in sealing a layer of air between the two. Very few metal hooks or staples were used in the construction, nearly all the timber being fastened by wooden pins and tenons and rope lashings. Restoration work is still being carried on under the direction of Ahmed Youssef, who was also responsible for much of the work on the furniture of Queen Hetepheres. When the restorations are finally completed, a further pit lying a few yards to the west of the present pit will be opened, since it it believed that another boat probably awaits discovery there.

The reason for the marvellous state of preservation of the timbers was that the edge of the pit had been rabbeted to receive forty-one roofing blocks, each weighing an average of sixteen tons. A smaller keying block at one end had to be removed before any of the larger ones could be approached. The pit is oblong in plan instead

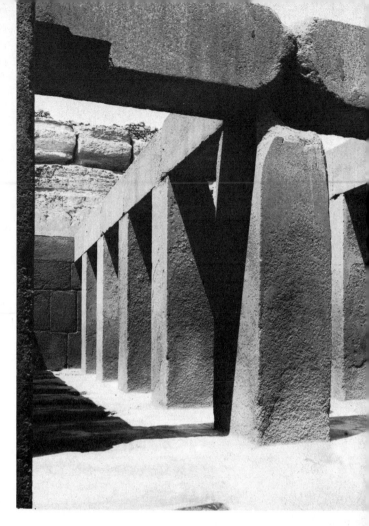

84 The interior of the Valley Temple of Khephren built of massive blocks of limestone faced inside and out with slabs of polished red granite. In the long hall there were originally twenty-three statues of Khephren carved in alabaster, grey schist and green diorite set at intervals along it. One of these statues (*Ill. 109*) was found buried in a pit by Mariette together with numerous fragments of others. It has been suggested that the body of the dead king was embalmed in a temporary pavilion erected on the roof, then ceremonially washed and purified in the ante-chamber before being carried in procession along the enclosed causeway to the Mortuary Temple and subsequently to the burial chamber within the pyramid

of the boat-shape of similar pits in the vicinity and this feature contributed to its air-tight sealing. The work was finished by Kheops' successor, Re-djed-ef, since his is the only royal name occurring in the workmen's graffiti and quarry marks painted on the blocks. Much speculation was aroused by the discovery of the boats, and they have been variously termed 'solar boats' or as boats for normal use on the Nile. In shape the uncovered specimen resembles those of secular use rather than the 'solar barques' and may have been used in the actual funeral procession of Kheops.

Ill. 115

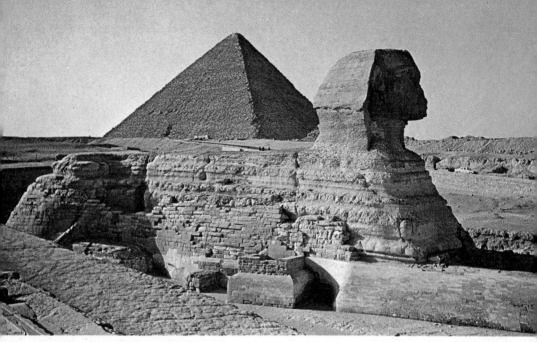

85 The Great Pyramid of Kheops, *c.* 2575 BC, from the south-east. In the foreground is the later guardian Sphinx which was hewn out of a knoll of rock left in the local quarry whence came the core blocks for the Second Pyramid of Khephren

Ill. 84
The best preserved of the mortuary temples at Giza is the Valley Temple of the Second Pyramid built for Khephren (Khafre), a successor of Kheops. It is constructed in massive local limestone faced inside and out with slabs of polished red granite. Such temples may be stone versions of a light pavilion in matting and reeds in which the corpse of the early kings underwent purification and embalmment, the fluids used in the latter process doubtless being returned to the near-by Nile for the greater fertility of Egypt. In the T-shaped hall of this Valley Temple the final funeral ceremonies were conducted before the coffined corpse of the king was taken along the covered causeway to the pyramid precincts. This hall is one of the most impressive interiors that the Old Kingdom architects have bequeathed to us, with its granite ceiling and unadorned square piers, also of red granite. Light was admitted by oblique openings cut in

86 The wooden poles of Queen Hetepheres' travelling canopy were covered in thin sheet gold. Fine linen hangings probably served as a mosquito net and within are her armchair, her bed with a head-rest at one end, and a gold-covered curtain box. *c.* 2580 BC

the tops of the walls where they met the roof, and fell upon the polished alabaster floor, casting a diffused glow upon the twenty-three statues of the king, hewn from green diorites, alabasters and grey schists, that stood at intervals along the walls. This temple is a complete realization in stone of the mortuary concept. It is designed and executed in that same uncompromising and austere spirit that raised the pyramids of Giza in all their accuracy and integrity and did not scruple to use the hardest of stones, polished basalts, granites and diorites, as well as alabasters and limestones in their construction. These pyramid complexes, too, contained closed repositories of statuary, reliefs, furniture and appointments on

Ill. 109

Ills. 77, 85

Ills. 86, 87

which the best of the artistic talent in the country was concentrated; and we are indeed fortunate that so much from this brilliant and classic period in Egypt should have survived. In particular mention must be made of the magnificent furniture of Queen Hetepheres, the mother of Kheops. This was found by George Reisner in 1925 in a small tomb chamber at the foot of a concealed shaft 99 feet deep, near the Great Pyramid at Giza. The chamber is the only royal tomb to have survived intact from the Old Kingdom, but the burial may in fact have been a re-burial; and although other theories are current, we shall accept Reisner's view that the queen was probably buried originally in a mastaba tomb near the pyramid of her husband, Sneferu, at Dahshur. Within the burial chamber the queen's funerary furniture was found, together with her alabaster sarcophagus and canopic chest. The sarcophagus proved to be empty. The canopic chest, in which the viscera were normally placed, after removal from the body during the process of mummification, still contained the queen's embalmed internal organs. This is most important in the history of mummification, since it is the earliest material proof of the practice of evisceration. Reisner postulated that soon after her interment, Hetepheres' original burial must have been disturbed by tomb-robbers who destroyed the body in removing its valuable jewellery and ornaments. Kheops must have been informed that his mother's tomb had been violated, but not that the body was missing. He had the complete funerary equipment transferred from Dahshur to the secret burial place at Giza for greater safety. Some of the objects buried with the queen were used by her during her lifetime, although the majority appear to have been made especially for her journey into the afterworld. Vases of gold, copper and alabaster, knives and razors of gold, a gold manicure set and copper tools were among the smaller finds. Folded and laid flat on the top of the

87 The restored carrying chair of Queen Hetepheres. The wooden parts are modern but the gold decoration is all original. An inscription on the back panel of the chair, inlaid in tiny gold hieroglyphs, gives her name and titles

sarcophagus was a canopy-frame of wood encased in sheet gold. This may have been fully erected in the queen's former and almost certainly larger burial chamber at Dahshur. Her bed and two arm-chairs were also partly covered in thin gold and her carrying chair bore an inscription inlaid in gold hieroglyphs set in ebony panels, giving her name and titles as 'The mother of the King of Upper and Lower Egypt, Follower of Horus, she who is in charge of the affairs of the harem, whose every word is done for her, daughter of the god, of his loins, Hetepheres'. The superb workmanship and design of these gold-sheathed chairs, boxes, bed and canopy with their coloured inlays in faience and carnelian (a reddish stone like chalcedony) reveal a taste at once opulent and austere, restrained and brilliant in the tradition of the age.

Ill. 87

The Later Buildings

It is clear, however, that the tremendous demands upon human and material resources which the building of the Giza pyramids made were not considered desirable or possible for the tombs of later kings. Even the third pyramid at Giza, that of Mykerinus (Menkaure), is appreciably smaller than its two rivals. The successors of the kings of Dynasty IV built their pyramids at Abusir and

Ills. 77, 88, 89

Ill. 90

95

88, 89 The pyramid of Mykerinus was the only one of the three at Giza to contain a decorated sarcophagus; Kheops' and Khephren's were perfectly plain. This early engraving shows the sarcophagus as it was found within the burial chamber by Colonel Vyse. It was made of basalt and its outer faces were carved with a fine panel decoration imitating the façade of a house (*Ill. 89*). Unfortunately the ship transporting it to England was lost in the Bay of Biscay

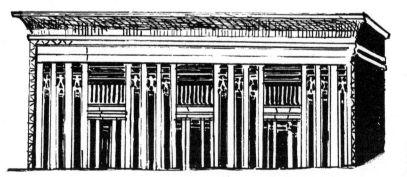

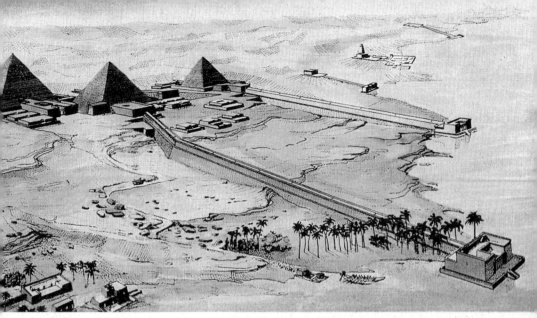

90 A reconstructed painting of the pyramid field at Abusir. From left to right the pyramids are those of Nefer-ir-ka-re, Ni-weser-re and Sahu-re. Elevated covered stone causeways run from the Valley Temples at the river's edge to the Mortuary Temples by the pyramids

Saqqara and abandoned the grandiose proportions and megalithic masonry of the Giza group. This decline in the size of the Pharaoh's tomb coincides with a decrease in the stature of the Pharaoh and a rise in the importance of Heliopolis where the sun-god Re was worshipped. The Pharaoh was now thought to be the son of the sun-god, and this idea which appears as early as Khephren is particularly in evidence after the middle of Dynasty V. According to a folk-story which probably originated at this time, the first three kings of Dynasty V were the sons of Re by the wife of a priest of Heliopolis. An innovation of the reigns of these kings is the sun-temple that each of them erected after the model of the sanctuary at Heliopolis and which differs fundamentally from other temples of the Old Kingdom. The best preserved of them is that of a later king of the Dynasty, Ni-weser-re, at Abu Gurob, *Ills. 91, 92* where the architect made ingenious use of the configuration of the ground to produce a temple complex on two

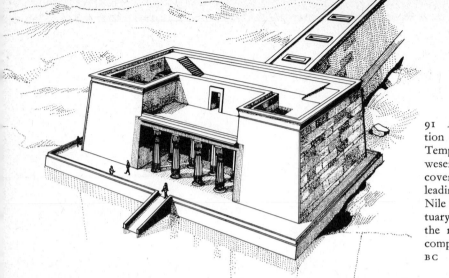

91 A reconstruction of the Valley Temple of Niweser-re with the covered causeway leading from the Nile to the Mortuary Temple and the main pyramid complex, *c.* 2420 BC

levels linked by an oblique sloping causeway. The sanctuary consists of a walled enclosure, 330 feet long and 250 feet wide, containing store-rooms and corridors with finely sculptured scenes. The ritual of the sun-cult was observed before altars in two open courts dominated by a squat obelisk, the cult image of the sun religion, which arose from a tall podium. A bizarre feature of the temple architecture, taking on more of the quality of a sculptural adjunct, was a large representation of one of the two 'solar barques' in which Re was thought to travel across the heavens. This was built of mud-brick a short distance south of the enclosure wall.

Ill. 92

In both the sun-temples and mortuary buildings of this dynasty great use is made of red granite columns in the form of date palms and clusters of papyrus stalks and these features give a delicate and more vital appearance to the architecture, perhaps under the influence of the earlier style of the Djoser complex near which two of the pyramids of this dynasty were built. Djed-ka-re Isesy built his pyramid, the 'Pyramid of the Sentinel' as its Arabic name terms it, to the west of Saqqara, and during the excavations many hundreds of fragments of reliefs, sculpture and architectural elements were found. It was only when the mortuary temple was excavated in 1946 that

Ill. 93

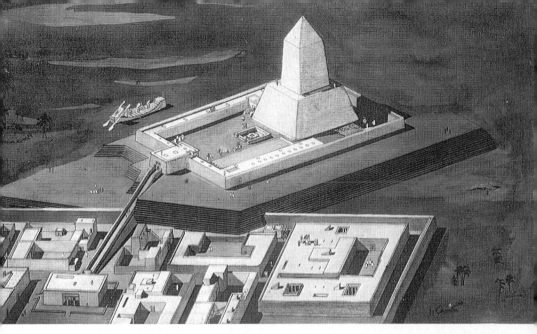

92 The best preserved of the sun-temples of Dynasty V, based on the sanctuary at Heliopolis, is that of Ni-weser-re at Abu Gurob. Here the architect made use of rising ground to build the temple complex on two levels connected by a sloping causeway. The sanctuary, a walled enclosure 330 feet long and 250 feet wide, is on the lower level and contained store-rooms and corridors with finely sculptured scenes. The sun-cult rituals took place in the upper court dominated by the squat obelisk on its tall base. Outside the temple walls, a mud-brick barque was built to symbolize the boat that carried the sun-god Re on his daily journey across the sky

93 A reconstructed cut-away view of the Pyramid Temple of Sahu-re showing the date-palm columns, Dynasty V, *c.* 2480 B C

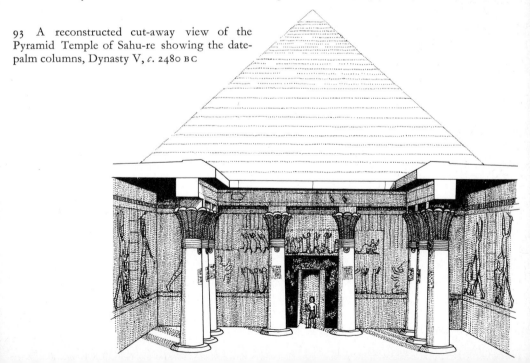

94 The north-east corner of the burial chamber in the pyramid of Wenis at Saqqara. The walls of the burial chamber and the vestibule are covered with hieroglyphs in vertical columns filled with blue paint. These are the so-called Pyramid Texts. They occur in a number of pyramids of Dynasty VI but this pyramid of Dynasty V is the earliest to be inscribed with them

the name of this king could be ascribed to the complex, since no inscriptions indicating the builder had been found in earlier excavations. The pyramid of Wenis lies a short distance outside the south-west corner of Djoser's temenos wall at Saqqara. It is completely ruined externally and heavily overshadowed by the neighbouring Step Pyramid being only 62 feet high. The pyramid was first entered in modern times by Maspero, and his findings astounded the archaeological world. Hitherto all pyramids had been thought to be uninscribed, but Maspero was able to bear the news to the dying Mariette that here was a pyramid with its burial chamber and vestibule covered in texts. These are the so-called Pyramid Texts, and although other examples have subsequently been found in a number of the pyramids of Dynasty VI and in other monuments, the Wenis texts remain the earliest examples. The interior rooms were built of Tura limestone, save for the west end of the burial chamber in

Ill. 94

Ills. 95, 96

95 The north-west corner of the burial chamber of Wenis. The black stone rectangular sarcophagus stands clear of the walls which are decorated with an elaborately carved and painted panel design and false door. The stone at this end of the chamber is alabaster, the rest of the room limestone (*cf. Ill. 94*). *c.* 2350 BC

96 The ground plan of the chambers and corridors of the pyramid of Wenis. The entrance from the north was originally blocked by three granite portcullises. On the east side of the square vestibule is a long narrow room with three statue niches and opposite, on the west side of the vestibule, the burial chamber with the sarcophagus at the west end

which the limestone was replaced by alabaster. An elaborate panel design and a false door were carved and painted on the alabaster, the rest of the chamber being covered with small carved hieroglyphs filled with a blue pigment in strong contrast to the white background.

The Pyramid Texts are actually a collection of spells or magical incantations and hymns, many of which, although translated, are still somewhat obscure in their meaning. The purpose of the Texts was to secure the apotheosis of the king and his well-being in the after-life. It was believed that the magical potency of the inscribed word was sufficient to guarantee this. Many of the words used

contained hieroglyphic signs depicting humans or animals, and it was thought that a danger might exist in having these potentially destructive elements so close to the deceased in his tomb. Hence the scribe drew deliberately mutilated signs with, for example, amputated legs or arms in the case of humans, or substituted less harmful and inanimate signs for the dangerous ones. A total of over seven hundred spells are known but in the pyramid of Wenis only some two hundred and twenty-eight occur. The choice of polished granite, basalts and smooth alabaster blocks for the construction, however, continues the tradition of Dynasty IV.

The advent of Dynasty VI saw no violent change in the character of such architecture so far as can be judged from the little that has been excavated. The last great monument of the age, the pyramid complex of Pepy II, fully maintains the fine standard of craftsmanship of the Old Kingdom and despite a tendency towards *Ill. 97* formalism in its relief decoration remained a source of inspiration to later generations anxious to recapture a little of their past grandeur. Some of the reliefs found in this complex, however, had been copied from those of earlier kings. Thus a scene from the pyramid temple of Sahu-re of Dynasty V showing the Pharaoh smiting Libyan foes is repeated line for line in the funeral monument of Pepy II, even to the names of the wife and two sons of the captive Libyan chief. It is, however, probably that Sahu-re's relief is not the original either, and the whole scene represents some symbolical event lost in the mists of the Archaic Age. An unusual feature differentiated this pyramid from its predecessors in that it had a girdle wall built close up against its base as well as the usual temenos wall surrounding its complex of mortuary buildings. Originally the girdle wall rose as high as the second or possibly the third course of the pyramid's casing. That it was erected subsequent to the

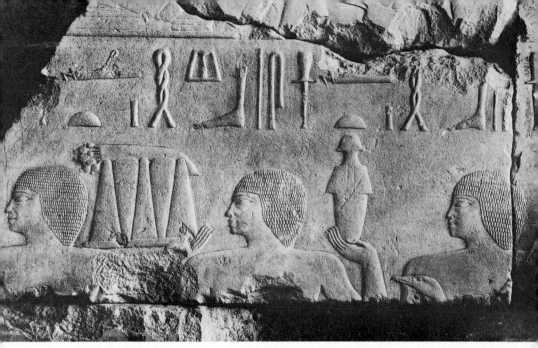

97 Part of a limestone relief from the Mortuary Temple of Pepy II showing estates bringing gifts. The relief carving of the heads and of the glyphs is in the best traditions of the Old Kingdom

main building is proved by its being built directly against the finished lower casing and also by the fact that several buildings were dismantled to accommodate it. It ran completely round the pyramid except where it was broken on the east side by the mortuary temple built against the pyramid face.

This curious feature has never been completely or satisfactorily explained. It has been suggested that it was added to give the pyramid greater stability, possibly after the whole structure had been shaken by an earth tremor.

Sculpture of the Old Kingdom Dynasties III–VI

The Earlier Sculpture

Ill. 98

The ruins of the pyramid complexes have preserved some meagre traces of the statuary and reliefs that once formed part of their decoration and equipment, and it is from this sculpture above all that we are accustomed to measure the full achievement of Old Kingdom civilization. Clustered around the pyramid of the king were the mastaba tombs of his relatives, officials and mortuary priests, expressing in death a relationship in which they had stood in life to their dead lord, as though they thereby received a little of his immortality. For while the king was believed to rule after death among the gods much as he had done on

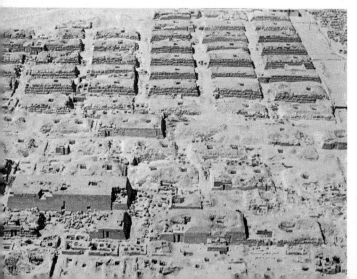

98 The tombs of relatives and favoured courtiers clustered around the tomb of the king, laid out regularly in rows with streets between. This mastaba field lies to the west of the Great Pyramid of Kheops at Giza

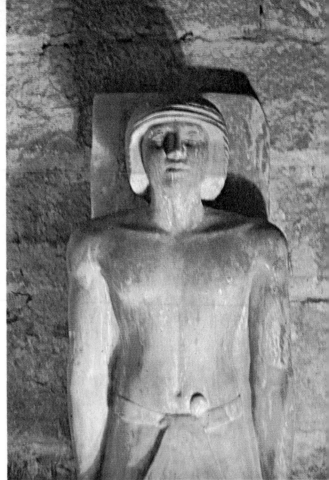

99 A cast of the statue of Ti walled up in the *serdab* of his mastaba at Saqqara. He is seen through the tiny eye-holes cut in the wall which allowed the statue to look into the offering chamber of his tomb (*cf. Ill. 65*). The original statue, *c.* 2450 BC, is in the Cairo Museum

100 The interior of the tomb of Ptah-iru-ka at Saqqara lined with painted standing statues of the owner cut from the rock. Some of the tombs of Dynasty V have multiple statues of the deceased either seated or standing in rows

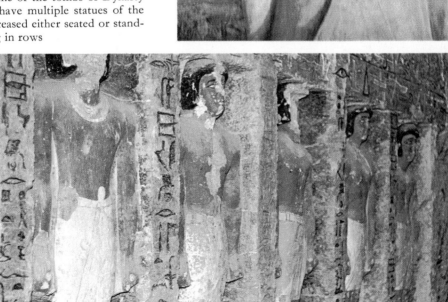

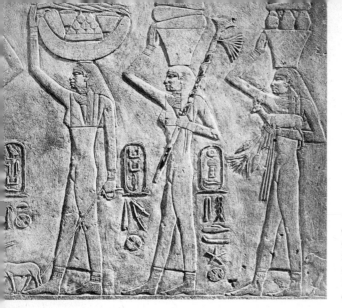

101 Girls representing the several estates of the Vizier Ptah-hotep carrying offerings and produce from the estates. The fruits of the earth are thus still supplied symbolically for the comfort of the dead. *c.* 2420 BC

earth, it is less clear what sort of after-life was reserved for his subjects. Several different beliefs existed together, but at this period it would seem that for private persons some kind of shadowy existence in their 'houses of eternity' was all they could expect, subsisting upon the offerings brought by pious relatives or magically materialized for them by the recitation of certain prayers. Originally much of the cult of the dead seems to have centred around the partaking of a funeral meal at the tomb, in which communion the deceased was supposed to join, but this rite early found graphic expression in a representation of the tomb-owner seated at table. Such scenes carved on wooden or stone slabs were let into a niche in the mastaba wall, and from this was elaborated, as the age advanced in prosperity and skill, a stone-lined chamber with painted reliefs, and *serdabs* containing statuary. Thus the sculptural furnishings of the pyramids were copied on a more modest scale for the mastabas of kings' children, ministers and courtiers.

Ill. 104

Ills. 99, 100

It is customary to regard artistic fashions as having been set by the king's craftsmen and followed more or less faithfully by his subjects, both in style and iconography. The picture seems true in its general outlines,

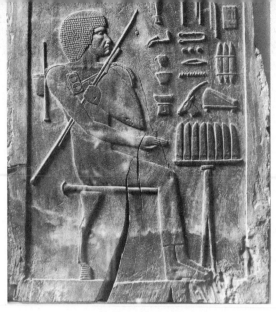

102 A wooden relief of Hesy-re from his tomb at Saqqara shows him seated at table holding his emblems of office and wearing a short curled wig. The legs of the stool upon which he sits should be compared with the forms in *Ill. 44*

103 Two statues of Kha-sekhem, one of the later Kings of Dynasty II, *c.* 2720 BC, were found at Hierakonpolis. He sits tightly wrapped in his jubilee cloak and wears the White Crown. Rebels falling headlong are carved around the statue base. The archaic character of the statue is evident in the position of the hands, a pose which later sculpture avoided (*cf. Ills. 61, 109*)

but so little of the royal sculpture has survived that it is hazardous to be too categorical. There are, moreover, certain Pharaonic themes such as the symbolical slaughter of the traditional foes, or the Jubilee Rites, which were quite inappropriate for representation in the tombs of private persons. On the other hand, the pilgrimage by boat to the 'Goodly West' (i.e. the hereafter) which enters the repertoire of subjects for decoration in mastaba chapels towards the end of the Old Kingdom does not seem to have been depicted in pyramid temples. Certain scenes, such as the assembly of personified districts, or nomes, offering their produce to the king at his accession

Ill. 101

104, 105 The Vizier Ptah-hotep seated at his table holding to his nose a salve container inscribed 'Finest perfume for Festival' whilst servants, shown in smaller size, bring offerings and the produce of his estates. Behind him to the left is a false door, carved in the belief that his *ka*, or spirit, could move freely through it. The statues of Re-hotep and his wife Nofret, *Ill. 105*, are not composed as a group but meant to be regarded as a pair. A restrained naturalism is evident in the painted surfaces and inlaid eyes but there are monumental tendencies in the simplified planes and underlying masses. Convention is followed in the skin colouring, reddish-brown for the man and a creamy yellow for the woman. Re-hotep was high-priest of Heliopolis and commander of the army, Nofret a member of the court. The statues, found intact in a tomb near the pyramid of Maidum, are the finest examples of early Old Kingdom painted statuary to survive, *c*. 2620 B C

or jubilee, are translated into the procession of personified estates making funerary offerings to their master.

Fragments of wood and ivory suggest that the carving of statues in these transient media had reached a fair competence by dynastic times, as is revealed by the almost *Ill. 52* complete ivory figurine of a king in his Jubilee robe. There is evident in sculpture as in architecture, however, the same impulse towards achieving a mastery in eternal stone, and it is in such hard rocks as diorite and basalt *Ill. 103* that the finest expression of the Old Kingdom sculptor is achieved. But throughout the period, limestone remains

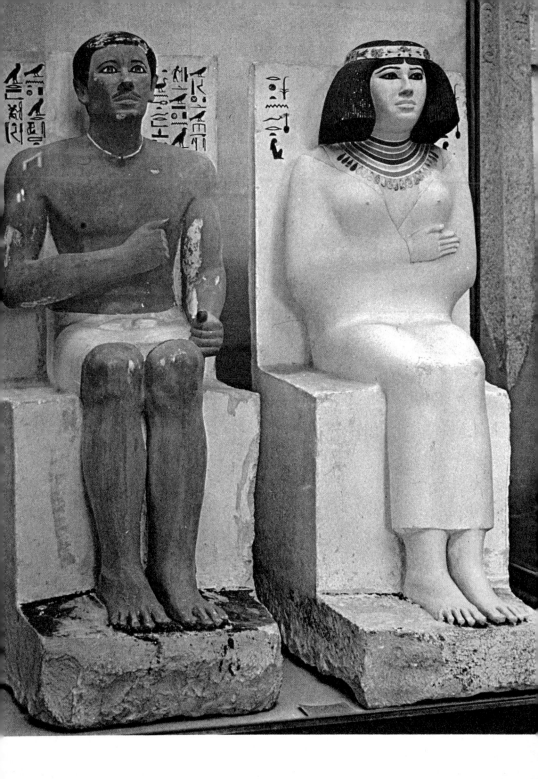

106–108 It is thought that the 'reserve heads' from Giza were placed in the tomb to act as a substitute should the body be damaged or destroyed. There is the same uncompromising spirit dominating these heads of a prince, probably a son of Kheops, and of his wife, as in the head of Hemon (*cf. Ill. 80*). *Ill. 108*, the bust of Ankh-haf (*c.* 2550 BC), has a curiously modern appearance and is unique amongst Old Kingdom sculpture. A skin of plaster of varying thicknesses covering the basic limestone was painted a light red and encouraged a more sympathetic handling of the surfaces

Ill. 102

Ill. 105

Ill. 80

the proper medium for relief, the only notable exception being the wooden panels of Hesy-re, a contemporary of Djoser. Limestone, too, is the material from which the bulk of private statuary was carved, and in which the first confident statement of the Egyptian sculptor has survived. These statues of Re-hotep and Nofret belong to the earliest years of Dynasty IV. In their restrained naturalism, with their painted surfaces and inlaid eyes, they seem to be at the end of a development which is lost to us, representing a lively vital intention, the equivalent in sculpture of the architecture of Djoser. There is something of the same irresolution between the lifelike surfaces and the monumental tendencies evident in the simplified planes and underlying masses. This conflict is composed in the slightly later statue of Hemon which is unpainted, though the inscription is inlaid with coloured pastes. The portraiture of the body is as individual as that of the face, and the arms are now arranged in a pose that so satisfied the subconscious desire of the Egyptian for a perfect equipoise of rival forces that it is repeated with minor variations until the end of Pharaonic art. The monumental character of this striking statue reveals the same intellectual approach, the same uncompromising and ruthless exploration of form, of which the geometrical

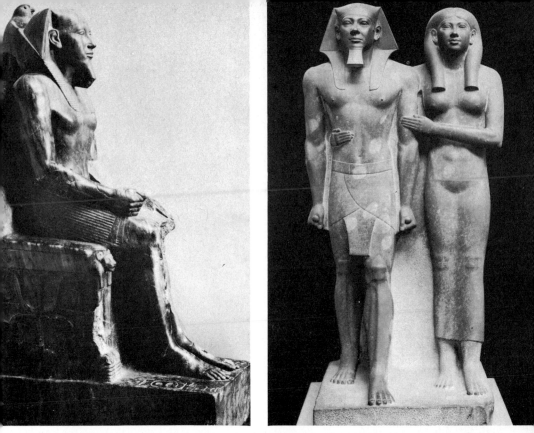

109, 110 One of the twenty-three statues in the long hall of the Valley Temple of Khephren
(*Ill. 84*),this surviving statue of the king superbly expresses the lonely majesty of the god-king
sitting aloof on his high-backed throne, *c.* 2565 BC. In the slate statue of Mykerinus and his
wife (*Ill. 110*) the divine solitary majesty of the earlier statues is subtly transformed into the
essential humanity of husband and wife by the appealing embrace

perfection of the Great Pyramid is the architectural
counterpart. This spirit is particularly dominant in the
so-called 'reserve heads' made in unpainted limestone to
be placed in the burial chambers of some of Kheops'
relatives and retainers. In the next generation a trans-
fusion of this style by a warmer and more naturalistic
feeling is to be seen in the bust of Ankh-haf where a
coating of plaster laid over the limestone has encouraged
a more plastic handling of the surfaces. These heads, and
the statues of Re-hotep and Nofret with their highly per-
sonal portraiture, must be regarded as products of the
royal workshops and made at the king's command. The

Ills. 106, 107

Ill. 108

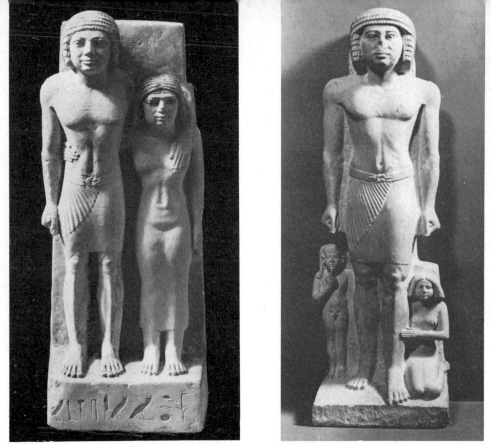

111, 112 The sculptor, helped by the traditions that the wife should be smaller, has achieved a natural pose and an expression of an unaffected, personal relationship in this statue of the steward Memy-sabu and his wife. The Overseer of the Granary Iruka-Ptah (*Ill. 112*) is represented in the old tradition, with his wife and child on a much smaller scale. His son has his finger to his mouth in the typical gesture of a small child and wears his hair long at one side in the 'side-lock of youth'

Ill. 109

Ill. 110

Ill. 113

most impressive of such pieces is the diorite statue of Khephren which once stood with its twenty-two companions in the hall of his Valley Temple. More than any other statue to have survived from Egypt, this superb specimen in a hard igneous stone expresses the apotheosis of kingship. In the same sculptural tradition, though quite different in its inner statement, is the unfinished pair statue of Mykerinus and his queen. The lonely and god-like majesty of the earlier statues of the dynasty has been subtly transformed into the essential humanity of the royal pair shown as husband and wife on an equal footing. The same feeling pervades the triads from the

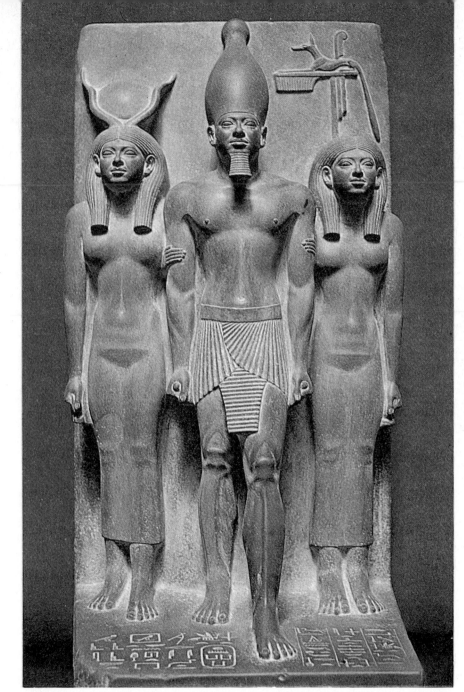

113 Mykerinus walking between two goddesses in an elaborate three-dimensional version of
the earlier themes showing the personified districts of Egypt bringing their offerings to the king.
He stands between Hathor and the goddess of the Jackal nome (or district) who wears her
emblem on her head. The goddesses have the features of the queen as is usual in Egypt

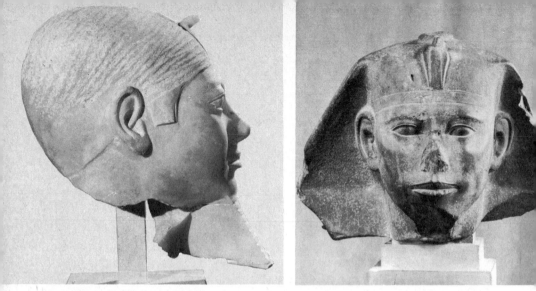

114 The growing humanity of the Pharaoh is particularly evident in the head of this statue believed to be that of Shepses-ka-f (*c.* 2500 B C). The translucency of the alabaster softens the contours and imparts a life-like glow to the modelling and represents a climax in the Old Kingdom sculptural style

115 The more complete of two portrait heads of King Re-djed-ef who began the construction of a pyramid to the north of Giza at Abu-Rawash. Of quartzite sandstone and life-sized, it is among the first surviving statements of royal statuary in Dynasty IV. The underlying bony structure of the face has been suggested in the hard stone by the greatest economy of means. The piece acts as a bridge between the vanished statuary of the reign of Kheops and the portraits of Khephren and Mykerinus, the successors of Re-djed-ef (*cf. Ills. 109, 110*), *c.* 2550 B C

Mykerinus Valley Temple where the goddesses are shown with the features of the queen, as is usual in Egypt. These groups are but elaborate three-dimensional versions of a theme which appears a little earlier in relief showing personifications of the various districts of Egypt bringing their tribute to the reigning king. The dyad of Mykerinus supported by his queen is really a development of the statues made separately but meant to be regarded as a pair, as for example those of Re-hotep and Nofret. Husband and wife are now shown in a simple and appealing embrace, a pose which appears in contemporary relief. Often the embrace is mutual as in certain private sculptures which quickly adopted the idea. An earlier style, however, which represents the wife and children on a much smaller scale than the master of the household,

Ill. 111

Ill. 112

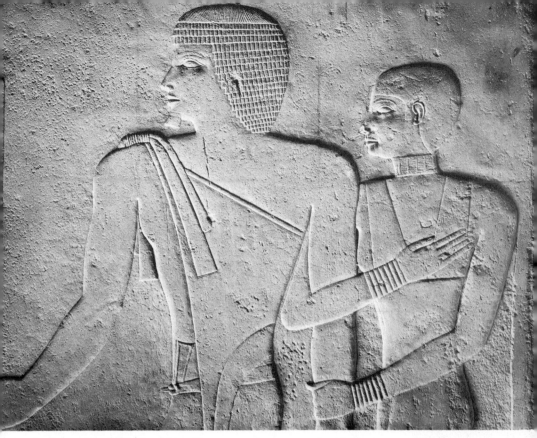

116 Prince Khufu-khaf and his wife composed as a group in this limestone relief contrast with the separate treatment of Re-hotep and Nofret (*Ill. 105*). Khufu-khaf, a son of Kheops, is receiving offerings supported by his wife. The drawing in an austere, restrained style makes its effect by purity of line and is one of the earliest representations of such a group, *c*. 2570 B C

is not superseded and the two exist side by side without conflict.

The humanization of the Pharaoh which may be sensed in the dyad and triads of Mykerinus is particularly evident in the head of a statue believed to be of Shepses-ka-f where *Ill. 114* the translucency of the alabaster softens the contours and imparts a life-like glow to the modelling. This head represents the climax of the Old Kingdom sculptural style which virtually spans the period of Dynasty IV. What has survived in royal statuary from the rest of the period, though often highly competent, shows a certain *Ill. 115* formalism.

117 Mereruka, the vizier of king Tety, walks through the false door in his tomb at Saqqara ▷
with startling realism to partake of the offerings left for him. Not all tombs had such a carved
figure but all had a false door (cf. Ill. 104) through which the ka, or spirit, of the dead man could
easily pass

The reliefs from the pyramid temples of the dynasty exist in mere tantalizing scraps, which, however, reveal the same assured yet precise drawing and masterly technique that are evident in the statuary, though they also suggest a striving rather than an achievement. One of the best preserved examples of this restrained style are the reliefs from the mastaba chapel of one of the sons of Kheops, Khufu-khaf and his wife receiving funerary offerings. The painted reliefs of the end of the dynasty show a decline from this high standard, largely because they are carved in a coarse limestone which has to be supplemented with plaster. Their bright colours, however, anticipate the lively scenes in the private chapels of the next dynasty when the many craftsmen trained on the enormous funeral monuments at Giza were free to undertake commissions for court officials at Saqqara.

Ill. 116

Ill. 117

The Later Sculpture

While the more modest tombs of the kings of Dynasty V made less demands upon the reserve of artistic talent, it is clear that the standard of craftsmanship in the palace workshops is well maintained particularly at the beginning of the dynasty.

Ill. 123

Royal statuary is rather rare, the few examples being of unequal quality, and suggesting that the triumphs of the Dynasty IV sculptors had now been reduced to a successful formula, which, however, was less effective the further it moved from its fount of inspiration. Thus Firth found in the Mortuary Temple of Weser-ka-f at Saqqara a magnificent statue-head of the king in red granite, three times life size, which provides the only evidence for colossal statuary in the Old Kingdom. It is firmly in the tradition of the best work of the preceding Dynasty, as is also the slate head of a statue of the same king recently found in the re-excavated ruins of his sun-temple at

Ill. 118

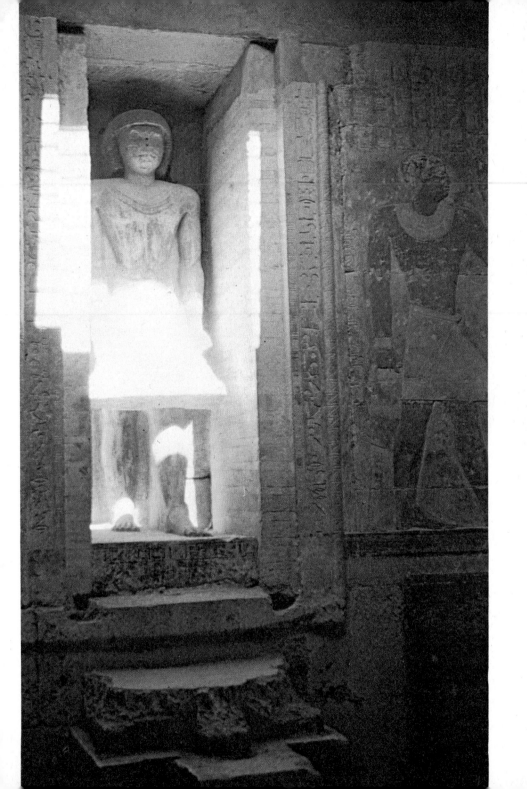

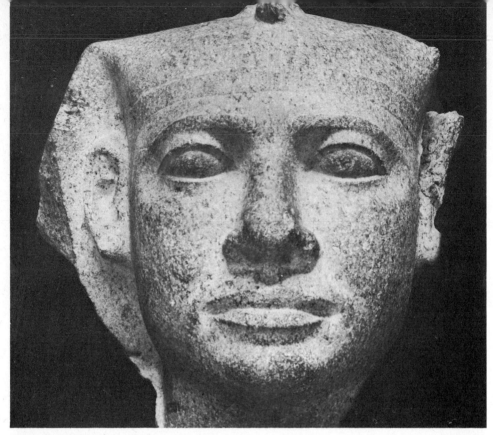

118 Found in his Pyramid Temple at Saqqara this head of Weser-ka-f of Dynasty V is a unique example of colossal sculpture in the Old Kingdom. The broad treatment of the features, in part dictated by the hard stone, have given the king a monumental aloofness and majesty. The eyes are boldly outlined and modelled and the *nemes* head-cloth which the king wears is without detail. *c.* 2495 BC

Ill. 119

Abusir. On the other hand, the diorite dyad of Sahu-re and the god of the Koptos nome, now in New York, shows a certain falling off in the handling of the hard stone, in the proportions of the figures and in the somewhat banal expressions of the features of both king and god. It may well be, however, that the statue is not fully representative, but is the product of a mere second-line sculptor from Memphis who was considered adequate enough for a commission from a remote provincial centre such as Koptos.

Ill. 120

The royal sculptures of Dynasty VI are also scanty. The copper-sheathed statues of Pepy I and his son are too

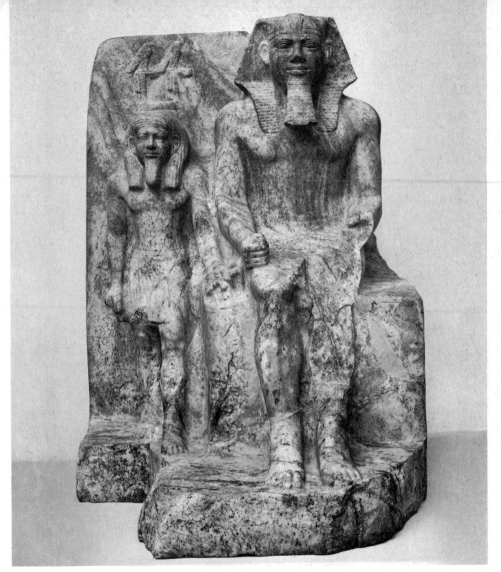

119　Only fragments survive of the statues of Sahu-re of Dynasty V except for this diorite dyad. The king is shown seated and accompanied by the god of the Koptos nome (or district), a male figure standing on the king's right wearing a ceremonial beard and his sign above his head. In his left hand which rests against the king's throne he holds the *ankh*, symbol of life. The seated attitude of the king recalls the statue of Khephren (*Ill. 109*); and the group as a whole the Mykerinus statues (*Ills. 110, 113*) of Dynasty IV. Nevertheless, the hard stone is not so well worked, the final polish not so good nor the body so well proportioned as in the work of the preceding Dynasty IV. This is strange since the reign of Sahu-re is noted for its ability to deal with hard and difficult stones (*Ill. 93*). A possible explanation is that the statue, reputed to come from Koptos and bought in Luxor, may represent the work of a provincial school of sculpture remote from the royal court at Memphis, *c.* 2480 BC

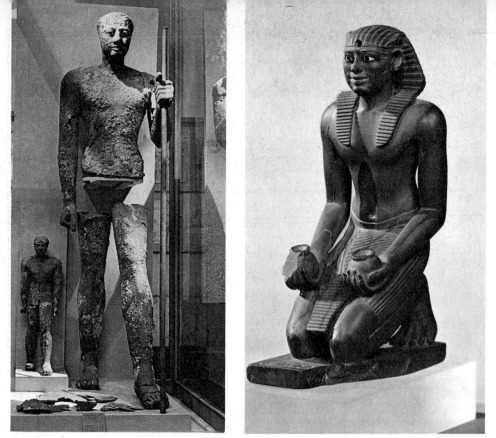

120 The copper-sheathed statues of Pepy I and his young son from Hierakonpolis, are the only copper sculptures to survive from this period and are perhaps too corroded to give a complete impression of the development of this class of sculpture. The eyes are inlaid and the missing portions of the statue, the crown and the stiff kilt, were probably of gilded plaster

corroded to give a reliable impression, but the votive statuettes in the Brooklyn Museum show that new forms may have been developed during the later Old Kingdom, when we find the divine Pharaoh deigns to kneel to the gods. Objects of precious metals from this period of Egyptian history are very rare. Mention has already been made of Dynasty I jewellery found by Petrie at Abydos, in the tomb of King Djer, and the ivory plaques which list the precious beads that composed necklaces from Naqada. At Hierakonpolis, as well as the copper-sheathed statues of Pepy I and his son, Quibell found a magnificent falcon head of

Ill. 121

Ill. 49

Ill. 122

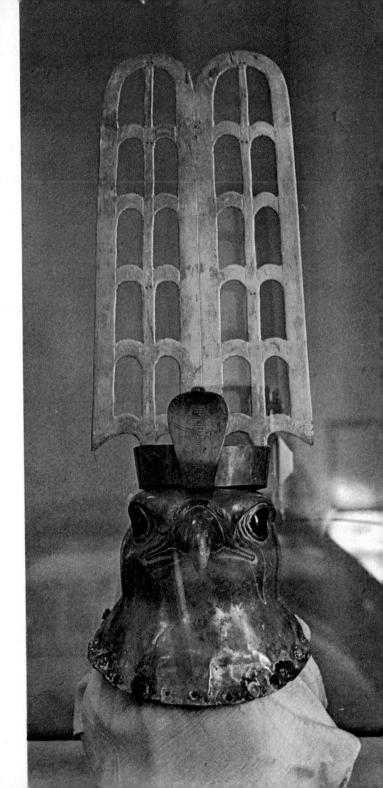

121 The earliest known example of a god-king shown kneeling to present offering to another god is this green slate statue of Pepy I, *c.* 2330 BC. The statue is exceptional for its lively realism – arms and legs have been completely freed from stone fillings and the splayed-out toes and grasping hands have carefully finished nails. Inlaid eyes enhance the alert, lively expression of the face and the hole drilled in the front of the *nemes* head-dress was for the insertion of a royal uraeus, the guardian cobra of the king

122 From Hierakonpolis and one of the finest examples of goldsmith's work of the Old Kingdom is the gold falcon's head. An extremely life-like appearance is given by the beady eyes of polished obsidian. The falcon wears a crown with the extended uraeus serpent before it and tall plumes above. It formed part of a composite statue and was fastened by copper nails, which have left traces of green corrosion, to a body which was probably made of copper-sheathed wood

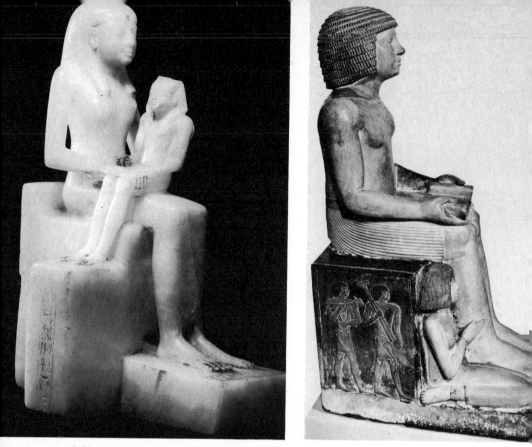

123 A king was ruler from birth. The child, though on its mother's knee, is shown as a miniature adult, in all the trappings of a Pharaoh. The statue, in alabaster, is of King Pepy II nursed by Queen Ankhnes-mery-re, *c.* 2275 BC

gold. This object is surmounted by tall golden plumes, and the life-like beady black eyes are formed from a rod of obsidian passing right through the head, its ends being highly polished. The small holes that are pierced round the base of the neck show traces of green copper corrosion and in all probability therefore the head once formed part of a composite statue, being attached to a body of wood or other material by copper nails. The statues of Pepy I and his son are also similar composite statues, since the missing crowns and kilts would have been composed of more perishable material such as gilded plaster. The falcon's head is one of the finest examples

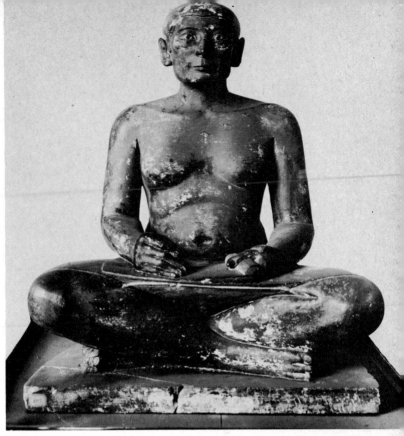

124 An innovation of the seated statuary of the late V Dynasty are the scenes in relief on the side of the block-seat and the omission of the back-plinth. This statue of Sekhem-ka shows him seated with an open scroll upon his knees inscribed with lists of offerings. His wife sitting gracefully beside him, her hand resting on his right leg, is still shown on a smaller scale. The side panels show two servants carrying offerings, a goose and lotus stalks and a calf. *c.* 2400 BC

125 The official Kay(?) represented, squatting, as a scribe. His skin is reddish-brown, his hair black. The eyes which give the statue such an alert, alive appearance are made of alabaster, crystal, black stone and silver all set in a copper surround. *c.* 2480 BC

of goldsmith's work of the Old Kingdom to have survived and may be dated to the same period of Dynasty VI as the statue of Pepy I.

In private sculpture more variety is apparent owing to the greater wealth of examples. One new type of statue is that of the owner as a scribe writing or reading. Such compositions have not so far been found among royal sculptures, though the Pyramid Texts speak of the king as acting as the secretary of the gods. Much of this private statuary is of wood which was designed to be covered with a skin of painted gesso (plaster and glue), though few of these carvings now survive in anything

Ill. 124

Ills. 43, 125

Ills. 126–128

123

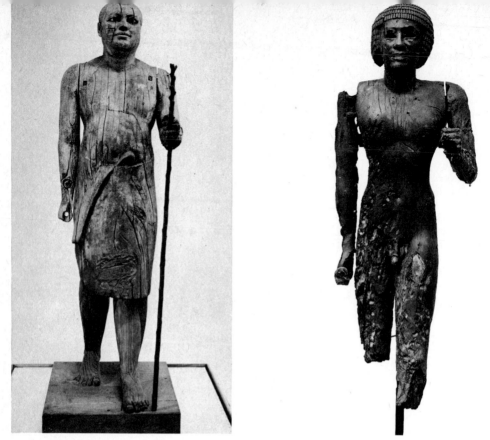

126 The wooden statue of Ka-aper has been known since its discovery as the 'Shekh-el-beled', or village headman. He was a priest, and a high state official. There was originally a thin layer of stucco over the wooden surface which has since disappeared together with the colouring. The eyes were made of quartz and crystal inserted in a copper surround

like their pristine condition. Often such funeral furnishings were the gift of the king to a favoured courtier and with the increasing diversion of wealth into private hands as the period advanced such patronage was spread downwards. There appears, for instance, a number of named statuettes of servants in the tombs of their masters who thus secured for them a kind of memorial. The prime intention, however, was that such statues should show the servant at his daily tasks serving by magic the needs of his dead master. In the carving of these minor though lively works of art, a rather sardonic attitude on the part of the artist towards his subject is often apparent, as

Ills. 129, 130

127 The wooden statue of Senedjem-ib-mehy, an architect and vizier of King Wenis is unusual amongst Old Kingdom statues of adults in showing the subject naked, though there are a few other similar nude statues known. The wood is much damaged but the carving shows a great deal of vigour. Like Ka-aper (*Ill. 126*) he strides forward and also would have carried a long staff in his left hand. He still retains in his right hand the baton which, however, is missing from Ka-aper's statue, and wears a typical short curled wig. *c.* 2360 BC

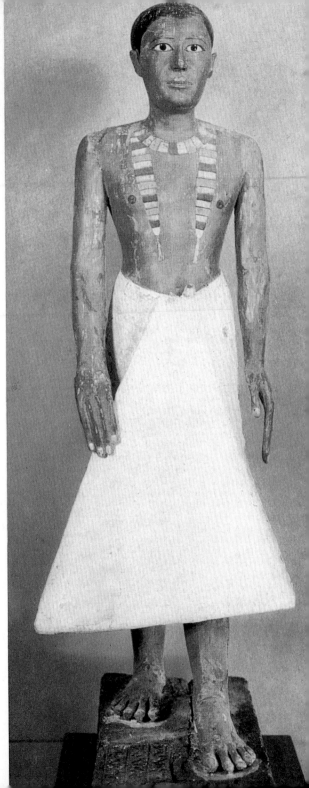

128 Few wooden statues of the Old Kingdom survive complete with their original paint. This statue of the Overseer of the King's Tenants, Methethy, is one of the finest. It dates from *c.* 2360 BC and comes from his tomb at Saqqara

129, 130 This limestone statuette is typical of a number which show a young woman grinding corn with a rubber. It dates from *c.* 2500 B C. *Ill. 130* shows an emaciated servant, modelled in terracotta, crouching and grasping a trussed gazelle behind his neck, *c.* 2200 B C

though the sanctions that applied in representing his betters had for the moment been lifted. For an instant we have a glimpse into a humbler world than that of the composed, athletic and well-nourished *élite*.

Ills. 131–133 The glory of the sculpture of this later period, however, are the reliefs that decorated the walls of the royal temples during early Dynasty V. The astonishing delicacy and minuteness of the carving and the sensitive drawing give an impression of supreme technical and artistic mastery, even in the wretched fragments which are all that have survived. The iconography of these scenes is expanded to include a number of novel subjects apparently introduced by the sun-cult of this dynasty with its interest in the calendar and time-measurement. In addition to the representation of Nile gods and district gods bringing the riches of Egypt to the king, there appear personifications of the three seasons, each being accompanied by characteristic animals and plants. The complete cycle of work in the fields was shown as a sort of visual hymn of praise to the sun-god for all his bounty. But as so often in Egyptian thought, where meaning exists on several levels at the same time, these scenes express one of the earliest attempts by Man to come to terms with the

131 Few fragments of the delicate sculptures and relief of the early Vth Dynasty that once adorned the royal temples survive. This fragment from the funerary temple of King Weser-ka-f at Saqqara, *c.* 2500 BC was part of a hunting scene. The many birds of the marshes, including a hoopoe and ibis, are shown in their native habitat

132, 133 Details of the public life of the king were recorded on the limestone walls of the funerary temple of King Sahu-re at Abusir, *c.* 2480 BC. He is shown shooting with a bow and arrows, followed by his divinized *ka*. The eye was probably inlaid as in some contemporary statues. *Ill. 133* is a detail of the king's kilt from another part of the relief showing its intricate pattern and pleats

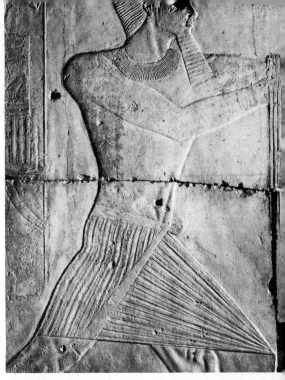

134　The work in the fields is richly illustrated in this relief from the tomb of Mereruka at Saqqara, *c.* 2350 BC, which contains some of the finest reliefs of the period. On the extreme left of all three registers are offering bearers carrying the first fruits of the field. In the upper register, asses are being assembled and loaded with panniers for carrying sheaves of corn. Above, the hieroglyphs give colloquial expressions and comments: 'Gee up!' and 'Ho-Ho you slow coach!'

universe around him by reducing it to an orderly system. The creation of the world was symbolized by the emergence of the new land like the Primaeval Hill from the flood waters as the inundation of the Nile receded. The world of nature was represented by the scenes of hunting, fishing and fowling, the propagation of animals and all agricultural pursuits from sowing and reaping to beekeeping and stock-breeding. Lastly the achievements of Man were recorded, whether as craftsman, administrator or warrior. Throughout all these scenes, in fact, there runs a connective thread of Man in all his activities from the games of his childhood to the solemn rites at his tomb door. While only fragments of this classic art remain, complete extracts from the same scenes are better preserved in the versions carved in private tombs during Dynasties V and VI, although the quality is poorer. It is from these coloured reliefs

In the centre register (left) flax is harvested and bound; on the right, corn reapers work in time to the music of a vertical flute. 'Oh folks, hurry up!' they say and 'This barley is very fine, mate!' On the ground to the right is a fat quail. In the lower register Mereruka, attended by his sandal-bearer, watches the sheaves of corn being thrown into a stack. Labourers with pitchforks toss the sheaves on to the threshing floor, where the corn is trodden out by goats, asses and oxen

that we gain so vivid and intimate a picture of country life in Ancient Egypt during the Old Kingdom, a teeming busy life observed with kindliness and humour – the field sports in marsh and wadi, the incidents of pastoral life, the boating on the Nile, the country crafts, the good life on the estate, music, games and dancing. There is a transient zest for life in these reliefs which is in dramatic contrast to the eternal calm of a spiritualized existence evident in the representations of the owner and his family. The field-labourers may contend with the recalcitrant ass, but no such struggle accompanies the confident spearing of fish by their master. The boatmen may fight among themselves on the water; their betters gaze impassively on, following the precepts that the edu-cated read in their books of instruction, for successfully cultivating the ideal of the 'tranquil' man – to be modest, patient and benevolent.

Ill. 134

Ill. 135

Ill. 136

The Civilization of the Old Kingdom

In the earliest dynasties it would appear that the king ruled the whole of Egypt as his private estate. As late as Dynasty IV the Palace with its adjoining official buildings was the 'Great House' (the Per-ao, whence the Hebrew 'Pharaoh', a circumlocution used much later to refer to the king himself) where the government of the country was conducted by chosen officials to whom the royal authority had been delegated. Many of them were sons or near relatives of the king who sponsored their upbringing and education, granted them property during their lifetimes and saw to the provision of their tombs and funerary endowments after death. This highly centralized state began gradually to split up from the later years of Dynasty IV when provincial governorships and other offices came to be regarded as hereditary appointments. The resources of the state treasury were eroded by gifts of land, exemptions from taxation, often in perpetuity, and alienation of income or property mostly for the benefit of the occupants of vast cites of the dead around the silent pyramids of their former rulers. On the other hand, the provincial governors, now fast becoming feudal potentates, no longer sought burial near the tomb of their overlord, but made their own cemeteries in the district capital, and clearly regarded themselves as little

135 This relief from the tomb of Ti at Saqqara shows the sculptor's great attention to detail. The naked drover carries a new-born calf on his shoulders across a ford. Anxiously it looks back to its mother, lowing, as she follows close behind. The impression of walking through rippling shallows is cleverly simulated

inferior to so many minor kings. After the long rule of Pepy II, a number of ephemeral Pharaohs, forming Dynasties VII and VIII, exercised uneasy authority for some twenty years, but the central authority had become too weak to hold back the rising tide of anarchy, and the civilization of the Old Kingdom collapsed with the political system that had created it.

Under the divine authority of the Pharaoh, Egypt during the Old Kingdom achieved a vigorous, characteristic and self-assured culture, untroubled by doubts and unfaltering in its belief that material success depended upon completing a practical education, doing right for the king, respecting superiors, and exercising moderation in all things. The ideal of the golden mean is as much in evidence in the calm and disciplined art as in the books of precepts which the sages wrote for their posterity. Such a civilization is essentially aristocratic. At first only the king mattered, but as his divinity came to be shared to some degree by his children and descendants, his exclusive powers, like the centralized authority of the state, began to disperse among a ramified privileged class who boasted of their acquaintance with the king and partook in some degree of his immortality. It was for them that all the economic and artistic activities were created. It

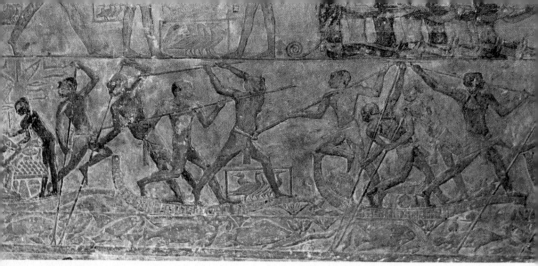

136 Boatmen are invariably shown fighting amongst themselves with disastrous consequences. These, from the mastaba of Ptah-hotep *c.* 2400 BC, attack each other with their long poles, a boat-man in the centre is being rammed in his stomach. Many of the expressions carved above the scenes are so colloquial as to defy translation except by such modern idioms as 'Slosh him!' The water below the boats is teeming with fish; and ducks and geese in baskets await dispassionately the outcome of the river battle

was they whose hopes of eternity were satisfied with tombs and endowments. They formed, however, no idle court nobility. Included in this *élite* were the architects, designers, writers, thinkers, theologians and master craftsmen of the day. The second king of Dynasty I was a noted anatomist; besides Imhotep, Prince Hardjedef, the son of Kheops, was celebrated long after his lifetime as a sage; Weni and Harkhuf were the first among a distinguished line of African explorers; the Viziers Ka-gem-ni and Ptah-hotep were moralists whose sayings were long handed down as literature. All this achievement was the exotic flower upon a plant whose root was the eternal Egyptian peasant, for ever toiling in the fields, living with his animals for the moment only, never far from sudden plague and famine, hedged around by grosser superstitions than those of his masters, but able unlike them to escape the inhibitions of polite society, and preserving intact the same sardonic gusto, the same manners and customs that have brought him virtually unscathed through five thousand years of changing history.

Ill. 135

Ill. 136

Bibliography

ALDRED, C. *Old Kingdom Art in Ancient Egypt.* London, 1949
 The Egyptians. London, 1961
BADAWY, A. *A History of Egyptian Architecture*, I. Giza, 1954
VON BISSING, F. W. et al. *Das Rē-Heiligtum des Königs Ne-Woser-rē*, I–III. Berlin, 1905–28
BORCHARDT, L. *Das Grabdenkmal des Königs Sahu-Rē.* 2 vols. Leipzig, 1910–13
BRUNTON, G. *Mostagedda and the Tasian Culture.* London, 1937
BRUNTON, G. and CATON-THOMPSON, G. *The Badarian Civilization.* London, 1928
CATON-THOMPSON, G. and GARDNER, E. W. *The Desert Fayum.* 2 vols. London, 1934
DUELL, P. *The Mastaba of Mereruka.* 2 vols. Chicago, 1938
EDWARDS, I. E. S. *The Pyramids of Egypt.* London, 1961
 The Early Dynastic Period in Egypt. London, 1964
 (Fascicule No. 25 of *Cambridge Ancient History*)
EMERY, W. B. *The Tomb of Hemaka.* Cairo, 1938
 Great Tombs of the First Dynasty. 2 vols. Cairo, 1949; London, 1954
 Archaic Egypt. London, 1961
FIRTH, C. M. and QUIBELL, J. E. *The Step Pyramid.* 2 vols. Cairo, 1935–36
FRANKFORT, H. *Kingship and the Gods.* Chicago, 1948
 The Birth of Civilisation in the Near East. London, 1951
GONEIM, M. Z. *The Unfinished Step Pyramid at Saqqara*, I. Cairo, 1957
HAYES, W. C. *The Scepter of Egypt*, Vol. I. New York, 1953
HÖLSCHER, U. *Das Grabdenkmal des Königs Chephren.* Leipzig, 1912
LAUER, J. P. *La Pyramide à degrés*, Vols. I–IV. Cairo, 1936–59
MERCER, S. A. B. *The Pyramid Texts in Translation and Commentary*, Vols. I–IV. New York, 1952
MONTET, P. *Les scènes de la vie privée dans les tombeaux égyptiens de l'ancien empire.* Strasbourg, 1925
NEWBERRY, P. E. 'Egypt as a field of anthropological research' in *Report of 91st Meeting, British Association.* 1923, 175 ff.
PETRIE, W. M. F. *The Royal Tombs of the First Dynasty*, Pts. I & II. London, 1900–1
 Prehistoric Egypt. London, 1920
PETRIE, W. M. F. and QUIBELL, J. E. *Nagada and Ballas.* London, 1896
QUIBELL, J. E. *Hierakonpolis*, Pts. I & II. London, 1900–2
 The Tomb of Hesy. Cairo, 1913
REISNER, G. A. and SMITH, W. S. *A History of the Giza Necropolis*, Vol. II. Cambridge, Mass., 1955
SANDFORD, K. S. and ARKELL, W. J. *Paleolithic Man and the Nile Valley.* 4 vols. Chicago, 1929–39
SMITH, W. S. *History of Egyptian Sculpture and Painting in the Old Kingdom.* Boston, 1949
 The Art and Architecture of Ancient Egypt. London, 1958
 The Old Kingdom in Egypt. London, 1962
 (Fascicule No. 5 of *Cambridge Ancient History*)
STEINDORFF, G. *Das Grab des Ti.* Leipzig, 1913
VANDIER, J. *Manuel d'archéologie égyptienne*, Vols. I–II. Paris, 1952–55
WAINWRIGHT, G. A. *The Sky-Religion in Egypt.* Cambridge, 1938

List of Illustrations

The author and publishers are grateful to the many official bodies, institutions and individuals mentioned below for their assistance in supplying illustration material. Illustrations without acknowledgement are from originals in the archives of Thames and Hudson.

46 Schist bowl from the tomb of Sabu at Saqqara. Dynasty I. Cairo Museum. Photo courtesy of Professor W. B. Emery

47 Slate basket dish. Dynasty III. Cairo Museum. Photo James Mortimer

48 Copper offering table and miniature ritual vessels from the tomb of Idi at Abydos, c. 2300 BC. British Museum. Photo John Freeman

49 Bracelets from the tomb of King Djer(?) at Abydos. Dynasty I. Cairo Museum. Photo courtesy of the Museum of Fine Arts, Boston

50 Ebony chair fragments from the tomb of King Djer(?) at Abydos. Dynasty I. Cairo Museum. Photo courtesy of Professor W. B. Emery

51 Compartmented wooden box from the tomb of King Djer(?) at Saqqara. Dynasty I. Cairo Museum. Photo courtesy of Professor W. B. Emery

52 Ivory statuette of a king from Abydos. Dynasty I. British Museum. Photo courtesy of the Trustees of the British Museum

53 Inlaid steatite disk from the tomb of Hemaka at Saqqara. Dynasty I. Cairo Museum. Painting by Mrs Winifred Brunton, courtesy of Professor W. B. Emery

54 Rock-carving in the Wadi Maghara of King Sekhem-khet. Photo John Freeman

55 Ivory sandal label of King Den from Abydos. Dynasty I. British Museum. Photo courtesy of the Trustees of the British Museum

56 Reconstructed view of the superstructure of the tomb of Queen Merneith(?) at Saqqara, after Lauer

57 Seated bronze statuette of Imhotep. Late period. Cairo Museum. Photo courtesy Director Général, Service des Antiquités, Cairo

58 Aerial view of the Step Pyramid and enclosure, Saqqara

59 Temenos wall of the Step Pyramid, Saqqara. Photo Peter Clayton

60 Reconstructed model of the Step Pyramid, Saqqara, seen from the south-east. Institut d'Art et d'Archéologie, Paris. Photo courtesy Dr J.-Ph. Lauer

61 Limestone statue of Djoser, from the serdab of the Step Pyramid, Saqqara. Cairo Museum. Photo Max Hirmer

62 Reconstructed view of the chapels and Jubilee Court of the Step Pyramid, Saqqara. Cyril Aldred after Lauer

63 Unfinished statue of Djoser, Step Pyramid, Saqqara. Photo Peter Clayton

64 The Step Pyramid, Saqqara, and a reconstructed chapel. Photo Peter Clayton

65 Copy of the statue of Djoser in his serdab at Saqqara. Original in the Cairo Museum. Photo Peter Clayton

66 Detail of stone imitation stake fence in the temenos wall of the Step Pyramid, Saqqara, after Drioton and Lauer

67 Papyrus half-columns in the northern court of the Step Pyramid, Saqqara. Photo Peter Clayton

68 Limestone relief of Djoser performing a jubilee rite set within faience panels. South Tomb within the Step Pyramid enclosure, Saqqara. Figure of the king 25 in. high. Photo Max Hirmer

94 Pyramid Texts in the burial chamber of the pyramid of Wenis at Saqqara. Photo Peter Clayton

95 Painted façade on the wall and sarcophagus in the burial chamber of the pyramid of Wenis at Saqqara. Photo Peter Clayton

96 Plan of the chambers beneath the pyramid of Wenis at Saqqara, after Fakhry

97 Limestone relief from the Mortuary Temple of Pepy II at Saqqara. Cairo Museum. Photo courtesy Director Général, Service des Antiquités, Cairo

98 Mastaba field to the west of the Great Pyramid at Giza. Photo Peter Clayton

99 Copy of statue of Ti in the *serdab* of his tomb at Saqqara. Original in the Cairo Museum. Photo Peter Clayton

100 Statues in the tomb of Ptah-iru-ka, Saqqara. Photo Peter Clayton

101 Relief of personifications of pyramid towns and estates bringing gifts in the tomb of Ptah-hotep, Saqqara. Photo courtesy Director Général, Service des Antiquités, Cairo

102 Wooden panel from the tomb of Hesy-re at Saqqara. Cairo Museum. Photo Max Hirmer

103 Slate statue of Kha-sekhem. Cairo Museum. Photo courtesy Director Général, Service des Antiquités, Cairo

104 Relief of Ptah-hotep seated at a table in his tomb at Saqqara. Photo Peter Clayton

105 Pair statues of Prince Re-hotep and his wife Nofret from Maidum. Cairo Museum. Photo Peter Clayton

106, 107 'Reserve heads' of a husband and wife, members of Kheops' family, from a mastaba at Giza. Museum of Fine Arts, Boston. Photo Museum of Fine Arts

108 Detail of the bust of Ankh-haf, from Giza. Museum of Fine Arts, Boston. Photo Museum of Fine Arts

109 Statue of Khephren from his Valley Temple at Giza. Cairo Museum. Photo Max Hirmer

110 Slate dyad of Mykerinus and Queen Kha-merer-nebty II from the king's Valley Temple, Giza. Museum of Fine Arts, Boston. Photo Museum of Fine Arts

111 Limestone dyad of Memy-sabu and his wife from Giza. Metropolitan Museum of Art, New York. Photo Metropolitan Museum of Art

112 Limestone triad of Iruka-Ptah, his wife and son from Saqqara. Brooklyn Museum. Photo Brooklyn Museum

113 Slate triad of Mykerinus flanked by two goddesses. Cairo Museum. Photo Roger Wood

114 Alabaster head of Shepses-ka-f(?) from the Valley Temple of Mykerinus, Giza. Museum of Fine Arts, Boston. Photo Museum of Fine Arts

115 Quartzite sandstone head of Re-djed-ef. Louvre. Photo B. V. Bothmer

116 Relief of Khufu-khaf and his wife on the west wall of his mastaba chapel at Giza. Photo Museum of Fine Arts, Boston

117 Statue of Mereruka in his tomb at Saqqara. Photo Cyril Aldred

118 Colossal red-granite head of Weser-ka-f from his Pyramid Temple at Saqqara. Cairo Museum. Photo Max Hirmer

119 Dyad statue of Sahu-re and the god of the Koptos nome. Metropolitan Museum of Art, Rogers Fund, 1918. Photo Metropolitan Museum

120 Copper-sheathed statues of Pepy I and his son from Hierakonpolis. Cairo Museum. Photo Peter Clayton

121 Kneeling votive statue of Pepy I, from Saqqara(?). Brooklyn Museum. Photo Brooklyn Museum

122 Gold falcon's head from Hierakon-polis. Cairo Museum. Photo Peter Clayton

123 Statuette of Queen Ankhnes-mery-re nursing Pepy II, from Saqqara(?). Brooklyn Museum. Photo Brooklyn Museum

124 Seated statue of Sekhem-ka from Saqqara. Northampton Museum. Photo H. Cooper

125 Seated statue of a scribe, probably the official Kay, from Saqqara. Louvre. Photo Archives Photo-graphiques

126 Wooden statue of Ka-aper, 'the village headman', from Saqqara. Cairo Museum. Photo courtesy Director Général, Service des Antiquités, Cairo

127 Wooden statue of the architect Senedjem-ib-mehy. Museum of Fine Arts, Boston. Photo Museum of Fine Arts

128 Painted wooden statue of Methethy from Giza. William Rockhill Nelson Gallery of Art, Kansas City

129 Painted limestone statuette of a servant woman grinding corn. Pelizaeus Museum, Hildesheim. Photo Pelizaeus Museum

130 Terracotta statuette of a porter with a trussed gazelle. Royal Scottish Museum, Edinburgh. Photo Tom Scott

131 Painted limestone fragment of a fowling scene from the Mortuary Temple of Weser-ka-f at Saqqara. Cairo Museum. Photo courtesy Director Général, Service des Anti-quités, Cairo

132 Relief fragment of Sahu-re shooting with bow and arrow, from his Funerary Temple at Abusir. Statt-liche Museen, Berlin. Photo Statt-liche Museen

133 Detail of the king's kilt. Relief from the Funerary Temple of Sahu-re at Abusir. Anatomy Museum, Uni-versity of Aberdeen. Photo Ana-tomy Museum

134 Painted limestone relief of work in the fields on the east wall of chamber A13, the mastaba of Mereruka at Saqqara. Painting by Vcevold Stre-kalovsky, courtesy Oriental Insti-tute, University of Chicago

135 Detail of a drover carrying a calf. Limestone relief on the north wall of the offering chamber in the tomb of Ti at Saqqara. Photo Max Hirmer

136 Boatmen fighting in a river scene. Detail of a limestone relief on the east wall of the chapel in the tomb of Ptah-hotep at Saqqara. Photo Peter Clayton

Index